Yoknapatawpha

images and voices

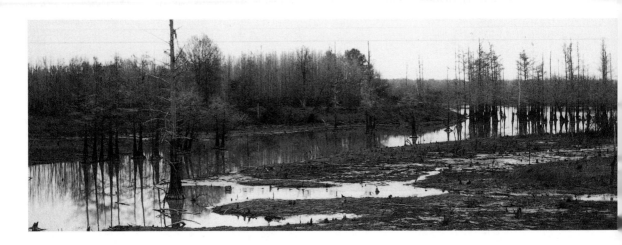

That's the one trouble with this country: everything, weather, all, hangs on too long. Like our rivers, our land: opaque, slow, violent; shaping and creating the life of man in its implacable and brooding image.

| *As I Lay Dying* |

The Yocona River as it becomes a floodplain before entering the Enid Reservoir. Flowing across the southern portion of Lafayette County, Mississippi, the Yocona was originally called the "Yoknapatawpha" (with variant spellings). From the Chickasaw language, this word is generally translated as "land divided" or "land torn apart," an ironic and prophetic meaning for the name William Faulkner gave his fictional county. Faulkner, however, understood *Yoknapatawpha* to mean "water runs slow through flat land."

Yoknapatawpha

images and voices

A Photographic Study of Faulkner's County

with passages from classic William Faulkner texts

George G. Stewart

foreword by Robert W. Hamblin

THE UNIVERSITY OF SOUTH CAROLINA PRESS

Published by the University of South Carolina Press
Columbia, South Carolina 29208

www.sc.edu/uscpress

Manufactured in the United States of America

18 17 16 15 14 13 12 11 10 09 10 9 8 7 6 5 4 3 2 1

Library of Congress Cataloging-in-Publication Data

Stewart, George G., 1937–
 Yoknapatawpha, images and voices : a photographic study of Faulkner's County / George G. Stewart ;
foreword by Robert W. Hamblin.
 p. cm.
 Includes bibliographical references.
 ISBN 978-1-57003-841-9 (alk. paper) — ISBN 978-1-57003-842-6 (pbk. : alk. paper)
 1. Faulkner, William, 1897–1962—Homes and haunts—Mississippi—Pictorial works. 2. Faulkner, William,
1897–1962—Settings—Pictorial works. 3. Yoknapatawpha County (Imaginary place) 4. Mississippi—Pic-
torial works. 5. Faulkner, William, 1897–962—Quotations. I. Faulkner, William, 1897–1962. II. Title.
 PS3511.A86Z97275 2009
 813'.52—dc22

 2009003436

Endsheets: Left: Faulkner's map of Yoknapatawpha County. From *Absalom, Absalom!* by William Faulkner.
Copyright 1936 by William Faulkner and renewed 1964 by Estelle Faulkner and Jill Faulkner Summers.
Reprinted by permission of Random House, Inc. *Right:* Map of north Mississippi

in memory of my mother

I do not know whether pilgrimages to the shrines of famous men ought not to be condemned as sentimental journeys. . . . The curiosity is only legitimate when the house of a great writer or the country in which it is set adds something to our understanding of his books.

| Virginia Woolf, *Essays* |

Feelings are bound up in place, and in art, from time to time, place undoubtedly works upon genius. Can anyone well explain otherwise what makes a given dot on the map come passionately alive, for good and all, in a novel? . . . What brought a *Wuthering Heights* out of Yorkshire, or a *Sound and Fury* out of Mississippi?

| Eudora Welty, "Place in Fiction" |

In a remarkable way landscapes which have inspired great regional literature take on a special luminosity which, though essentially borrowed and illusory, can seem to exist quite independently of its source.

| Michael Millgate, "Faulkner and the South: Some Reflections" |

Contents

Foreword

Few great writers are as solidly linked to a particular geographical place as William Faulkner. To read his novels and stories is to immerse oneself in the northeast corner of Mississippi that he identified, both physically and emotionally, as his home—more specifically the town of Oxford and the surrounding landscape of Lafayette County. Eventually, as demonstrated by the history of the annual Faulkner and Yoknapatawpha Conference at the University of Mississippi, Faulkner readers from around the world were drawn to visit his locale: to stand before the towering courthouse on the town square, to walk the red clay fields and hills of the adjacent countryside, to read the names and inscriptions on the local tombstones, to view the Tallahatchie and the Yocona (the two rivers he made famous), to stand in the latticed sunlight of the last remnants of the Big Woods, to observe the monuments and buildings and places that serve as the backdrop for the actions of his memorable, now-legendary characters.

It has long been an axiom of Faulkner criticism that his strength as a writer is intertwined with his link to his native region. Early on Ward Miner compared Faulkner to Antaeus, the Greek warrior whose great strength came from his renewed contact with his mother earth but whose strength was diminished when he was held aloft and could not touch the ground. "Just so it is with Faulkner," Miner observed. "As long as he maintains his intimate associations with Oxford, he maintains his strength as a writer. It is in his deviations from the world of Oxford that he loses his strength."

This was a hard lesson that Faulkner had to learn at the outset of his literary career, partly with the assistance of Sherwood Anderson. After producing a mediocre book of largely derivative poems featuring stylized landscapes and imaginary fauns and nymphs, a first novel about a war he never experienced, and a second novel about New Orleans dilettantes whom he detested, Faulkner heeded Anderson's advice to return to Oxford and write about the places and people he best knew. The result was one of the most remarkable turnarounds in literary history. "Beginning with *Sartoris*," Faulkner explained in his 1956 *Paris Review* interview, "I discovered that my own little postage stamp of native soil was worth writing about and that I would never live long enough to exhaust it."

The problem for contemporary readers and critics, however, is that the actual setting that plays such a crucial role in Faulkner's fiction is rapidly disappearing.

It had already begun to do so, of course, even as Faulkner wrote about it. In "The Bear" and still more specifically in "Delta Autumn," Faulkner laments the disappearance of the huge forests—a hunter's paradise populated with an abundance of bears, deer, and squirrels: "But that time was gone now. Now they went in cars, driving faster and faster each year because the roads were better and they had farther and farther to drive, the territory in which game still existed drawing yearly inward as his life was drawing inward, until now he was the last of those who had once made the journey in wagons. . . ." At the opening of "That Evening Sun," the narrator notes that similar changes are coming to the town of Jefferson: "The streets are paved now, and the telephone and electric companies are cutting down more and more of the shade trees—the water oaks, the maples and locusts and elms—to make room for iron poles bearing clusters of bloated and ghostly and bloodless grapes. . . ."

Such changes have accelerated since Faulkner's death. Former farmers of the area now work in factories and malls, and many of the farmers who are left grow soybeans and catfish rather than cotton. In the next county over, Toyota is building one of the largest automobile manufacturing plants in the United States. Oxford is no longer a sleepy country town, but an affluent, busy cultural center that is popular with retirees and tourists and is ranked as one of the top one hundred small towns in the United States. The large estate of John Grisham on the outskirts of town, to say nothing of his great financial success, stands in sharp contrast to Rowan Oak, as well as Faulkner's financial struggles. These days, if one wants to get a sense of what Oxford was like in Faulkner's day, he would be advised to pay a visit to the town square of Ripley or Holly Springs.

Toward the end of his career, Faulkner devoted an entire essay, "Mississippi," to the tremendous changes to his native land that he had witnessed in the course of his lifetime. That essay, a poignant valedictory dramatizing the tension between the inevitability of change and the celebration of lasting, cherished memory, expresses the very essence of Faulkner's notions of art and the artist. He wrote, as he explained in the illuminating preface to *The Faulkner Reader,* "to say No to death"; and all his efforts, like those of Marcel Proust, the writer with whom he has so much in common, were intended to salvage characters, events, places, and memories from the dustbins and sepulchers of history.

The photograph is a near-perfect analogue of these intentions. A photograph is the record of a single moment in time, a tangible artifact that seems momentarily to stop life and motion; yet, when viewed after the instant of creation, it simultaneously implies that such stoppage is an illusion, an artist's deception, since time moves on steadily, relentlessly, always bringing flux and change. Thus the photograph, like other forms of artistic expression, captures the paradoxical relationship between life and art. As Faulkner expressed it in an oft-quoted dictum from his 1956 *Paris Review* interview, "The aim of every artist is to arrest motion, which is life, by artificial means and hold it fixed so that 100 years later when a stranger looks at it, it moves again since it is life." Or again, "You catch this fluidity which

is human life and you focus a light on it and you stop it long enough for people to be able to see it." Faulkner's art, wonderful in its descriptive, evocative detail, may be understood as a succession of photographs: photographs captured in words rather than visual images, but photographs nonetheless.

For all these reasons, George G. Stewart's *Yoknapatawpha, Images and Voices* represents a significant contribution to an understanding of Faulkner's works. The book inevitably invites comparison with previous photographic depictions of Faulkner's world: specifically Martin Dain's *Faulkner's County* (1964) and *Faulkner's World* (1997), Willie Morris and William Eggleston's *Faulkner's Mississippi* (1990), and Thomas S. Hines's *William Faulkner and the Tangible Past* (1996). All these works are impressive and noteworthy, but to my mind Stewart's book is superior to each of them. Dain's work is a bit too much the product of a 1960s northern, liberal view of southern racism and poverty; Eggleston's color photographs tend to transform Faulkner's starkly realistic world into coffee-table art; and Hines's work is intentionally limited to the architectural features of Yoknapatawpha. In contrast Stewart's work strikes me as more balanced, more comprehensive, and more consistent with Faulkner's artistic design and purpose. Moreover the quotations from Faulkner are insightfully and carefully chosen to represent a wide variety of Faulkner subjects and themes, and the black and white photography seems perfectly suited to Faulkner's somber, tragic vision.

Stewart's book will be useful to those who have visited Faulkner's Oxford and environs—and even more useful to those who have not. For future generations of Faulkner readers, for whom that actual world will have almost completely disappeared, it will be indispensable.

| Robert W. Hamblin |

Center for Faulkner Studies
Cape Girardeau, Missouri

Preface

The dark world of Yoknapatawpha County of William Faulkner's major fiction, from *Sartoris (Flags in the Dust)* in 1929 to *Go Down, Moses* in 1942, is haunted by the past—particularly by the legacy of slavery—and paralyzed by obsession, violence, revenge, and defeat. Although interlaced with humor and acts of courage and sacrifice, it is essentially a tragic vision. When we read these novels and stories, the characters still convey vividly the timeless "problems of the human heart in conflict with itself"; but the models for these characters are dead, and the rural society in which they lived has changed significantly.

Consequently, to be faithful to Faulkner's dark vision of a South before 1943, a photographer often cannot locate that world in the current north Mississippi social scene. After sixty years a local resident on the streets of now-cosmopolitan Oxford may seem to be stepping from the pages of Faulkner's fiction, but those remarkable occasions are rare. But there were monuments, locales, architecture, and artifacts in or near Lafayette and Tippah Counties that were tangible images of Yoknapatawpha. Some of those still evocative objects and places have survived commercial progress, boosterism, and the ravages of time.

Acknowledgments

The photographs in this book were made during excursions to north Mississippi from 1989 to 1999. What began as a desire to take a few respectful pictures became more absorbing until, with encouragement from friends and Faulkner scholars, I developed a minor obsession, blending a longtime interest in the life and work of William Faulkner with my modest interest in the fine art of photography. In spite of distance and time, I searched north Mississippi for appropriate images, but I felt compelled occasionally to use the resources of agricultural museums in my home state of Georgia to represent rural lifestyles and objects that have disappeared from the Deep South. Faulkner's world is rapidly vanishing. Attempting to find tangible clues to his imaginary county can be exciting but also daunting, sometimes tentative and even misleading. Trying to recover his "actual into the apocryphal" can be just as elusive as Quentin and Shreve's attempting to understand Thomas Sutpen and his family's identity in *Absalom, Absalom!* I hope, however, that my photographic study is not only about Faulkner's private Mississippi but also a Faulknerian interpretation.

I wish to express my appreciation to several individuals and groups who made this book possible. Twenty-two of these photographs and a version of my preface appeared as a photo-essay, "Yoknapatawpha, Images and Voices," in the Fall 1998 issue of *Southern Cultures,* sponsored by the Center for the Study of the American South. I want to thank editorial consultant Lisa Eveleigh for her continued appreciation and Harry L. Watson, coeditor, and Laura Cotterman for their assistance. Three photographs and notes were featured in the concluding issues (2001) of the *Faulkner Newsletter & Yoknapatawpha Review,* edited by the late William Boozer.

I also thank the following Faulkner scholars for their support and suggestions: Robert W. Hamblin, Center for Faulkner Studies at Southeast Missouri State University; Sally Wolff-King, Emory University; Thomas L. McHaney, Georgia State University; Donald M. Kartiganer, University of Mississippi; Noel Polk, Mississippi State University; and Joseph R. Urgo, Hamilton College.

These individuals have been kind to answer my inquiries about the histories of their Mississippi towns or houses: William Lewis, Jr., about Oxford; librarian Tommy Covington about Ripley; William Griffith, curator of Rowan Oak and the University of Mississippi Museums; and Drs. Forrest T. and Janice B. Tutor, owners of Lochinvar.

In Atlanta I have been indebted to Barry Blackwell and his associates at Focus Atlanta for printing my photographs; to Anne A. Salter and her Philip Weltner Library staff at Oglethorpe University for bibliographic support; and to Chris Brooks, former administrator of the Tullie Smith Farm at the Atlanta History Center, for his assistance.

Finally the love and encouragement of my dear friend Virginia Reidy and my sister Margaret Dickey's family have been very meaningful. Among several friends, I would particularly like to thank Frank Hunter, John Haire, and, in memory, Larry Vonalt for their support.

PERMISSIONS FOR FAULKNER QUOTATIONS

From *Absalom, Absalom!* by William Faulkner, copyright 1936 by William Faulkner and renewed 1964 by Estelle Faulkner and Jill Faulkner Summers. Used by permission of Random House, Inc.

From *As I Lay Dying* by William Faulkner, copyright 1930 by William Faulkner and renewed 1958 by William Faulkner. Used by permission of Random House, Inc.

"Barn Burning," copyright 1950 by Random House, Inc., and renewed 1977 by Jill Faulkner Summers. "A Bear Hunt," "Beyond," copyright 1933 and renewed 1961 by William Faulkner. "A Justice," copyright 1931 and renewed 1959 by William Faulkner. "Hair," copyright 1931 and renewed 1959 by William Faulkner. "Mountain Victory," copyright 1932 and renewed 1960 by William Faulkner. "My Grandmother Millard," copyright 1943 by William Faulkner. "A Rose For Emily," copyright 1930 and renewed 1958 by William Faulkner. "Shall Not Perish," copyright 1943 by William Faulkner. "Shingles for the Lord," copyright 1943 by William Faulkner and renewed 1971 by Estelle Faulkner and Jill Faulkner Summers. "That Evening Sun," copyright 1931 and renewed 1959 by William Faulkner. From *Collected Stories of William Faulkner* by William Faulkner, copyright 1950 by Random House, Inc., and renewed 1978 by Jill Faulkner Summers. Used by permission of Monacelli Press, a division of Random House, Inc.

"Mississippi," copyright 1956 by William Faulkner. From *Essays, Speeches, & Public Letters* by William Faulkner, edited by James B. Meriwether. Used by permission of Random House, Inc.

From *Flags in the Dust* by William Faulkner, copyright 1929 and renewed 1957 by William Faulkner. Copyright 1973 by Random House, Inc. Used by permission of Random House, Inc.

From *Go Down, Moses* by William Faulkner, copyright 1940 by William Faulkner and renewed 1968 by Estelle Faulkner and Jill Faulkner Summers. Used by permission of Random House, Inc.

From *The Hamlet* by William Faulkner, copyright 1940 by William Faulkner and renewed 1968 by Estelle Faulkner and Jill Faulkner Summers. Used by permission of Random House, Inc.

From *Intruder in the Dust* by William Faulkner, copyright 1929 and renewed 1957 by William Faulkner. Copyright 1973 by Random House, Inc. Used by permission of Random House, Inc.

images and voices

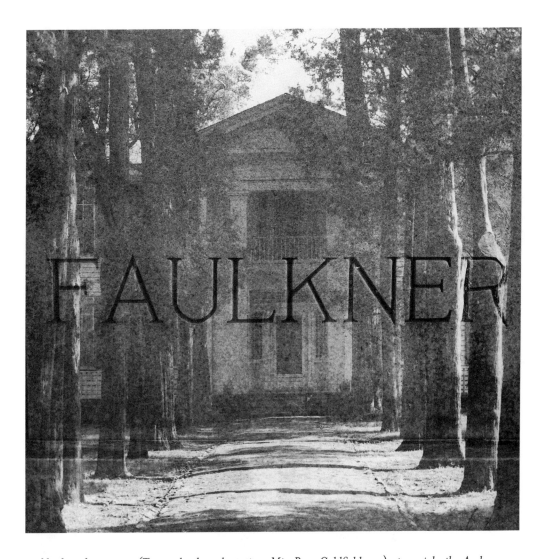

FAULKNER

and built a plantation—(Tore violently a plantation, Miss Rosa Coldfield says)—tore violently. And married her sister Ellen and begot a son and a daughter which—(Without gentleness begot, Miss Rosa Coldfield says)—without gentleness. Which should have been the jewels of his pride and the shield and comfort of his old age, only—(Only they destroyed him or something or he destroyed them or something. And died)—and died. Without regret, Miss Rosa Goldfield says—(Save by her) Yes, save by her. (And by Quentin Compson) Yes. And by Quentin Compson.

| *Absalom, Absalom!* |

Double exposure in photography may approximate stream of consciousness and doubling in narrative. Here the image of Faulkner's house in Oxford, Rowan Oak, dissolves into the grain of his headstone in Oxford's St. Peter's Cemetery. The effect is like the shadow of a memory, like the memory of "old ghost times" that haunts Quentin Compson, that haunts Faulkner's fiction. Faulkner's personal "demons" and literary ambitions, which caused some deprivation for his family, are reflected obliquely against the ruthless ambition of Thomas Sutpen, another shadow of Faulkner's great-grandfather William Clark Falkner. Rowan Oak inspired the ghost and then the story of Judith Sutpen in "Evangeline," an early basis for *Absalom, Absalom!*

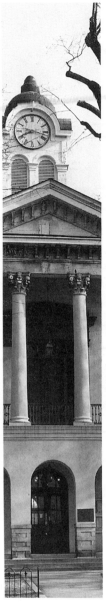

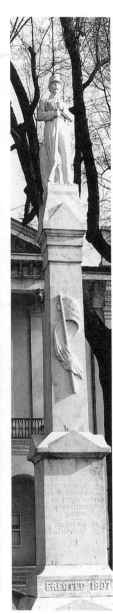
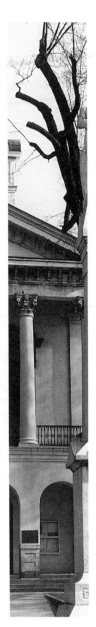

Jason came jumping across the square and onto the step.

With a backhanded blow he hurled Luster aside and caught the reins and sawed Queenie about and doubled the reins back and slashed her across the hips. He cut her again and again, into a plunging gallop, while Ben's hoarse agony roared about them, and swung her about to the right of the monument. Then he struck Luster over the head with his fist.

"Don't you know any better than to take him to the left?" he said. He reached back and struck Ben. . . . "Shut up!" he said. "Shut up!" . . . "Get to hell on home with him. If you ever cross that gate with him again, I'll kill you!"

| *The Sound and the Fury* |

A fragmented view of the Lafayette County Courthouse in Oxford as Benjy Compson might have seen it in his terrified confusion, his disorientation in past and present

A faint breeze soughed in the cedars like a long sigh, and the branches moved gravely in it. Across the spaced tranquility of the marble shapes the doves crooned their endless rising inflections.

| *Flags in the Dust* |

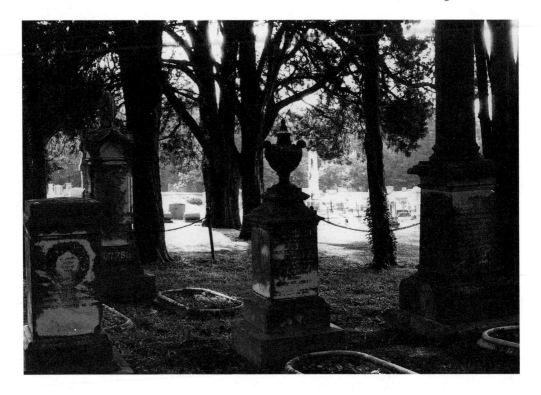

the late afternoon, the dark cedars with the level sun in them, even the light exactly right and the graves . . . looking as though they had been cleaned and polished and arranged by scene shifters

| *Absalom, Absalom!* |

A late afternoon view of St. Peter's Cemetery in Oxford, Mississippi, where Faulkner and several of his relatives and friends are buried. The gravestones surrounded by cedars mark the family plot of John Peyton Jones, a wealthy planter and a founder of Lafayette County. Jones's son-in-law, Jacob Thompson, who is buried in Memphis, provided the land for the cemetery and established this family plot. He was the most distinguished figure in antebellum Oxford's history: secretary of the interior under President James Buchanan and later inspector general and a confidential agent for the Confederacy. Thompson and his brother William, who is buried with the Jones family, were probably the basis for Quentin Compson's grandfather, General Jason Compson, who befriended Thomas Sutpen in *Absalom, Absalom!*

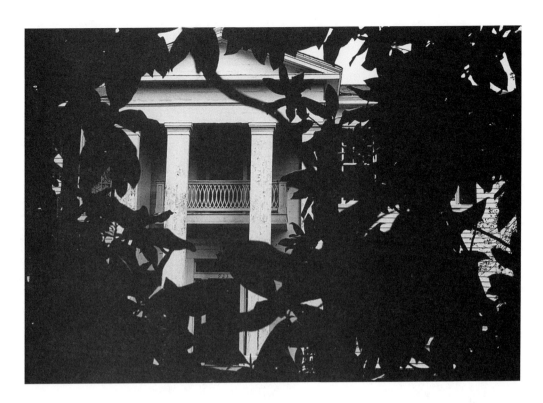

"Never you mind," Dilsey said. "I seed de beginning, en now I sees de endin."

. . . They reached the gate and entered. Immediately Ben began to whimper again, and for a while all of them looked up the drive at the square, paintless house with its rotting portico.

| *The Sound and the Fury* |

A view through magnolia leaves of the Thompson-Chandler mansion in Oxford, Mississippi, which is regarded as the Compson house, "Compson" being Faulkner's fusion of the family names "Thompson" and "Chandler." Built for William Thompson about 1860, the house remained unfinished until his daughter Lucretia later returned with her husband Dr. Josiah Chandler. The last of their children, Edwin Chandler, was mentally retarded and unable to attend school. He was confined to wandering in the front yard, which was surrounded by an ornate iron fence. Edwin is the source for Benjy Compson in *The Sound and the Fury*.

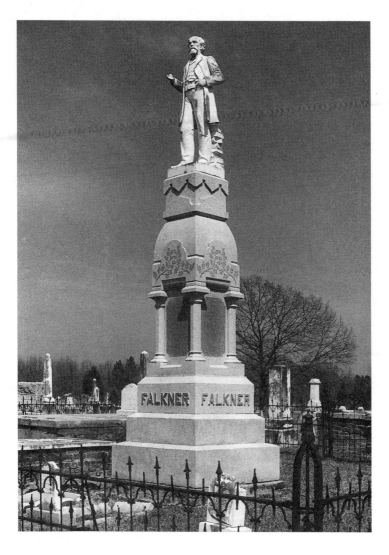

He stood on a stone pedestal, in his frock coat and bareheaded, one leg slightly advanced and one hand resting lightly on the stone pylon beside him. His head was lifted a little in that gesture of haughty arrogance which repeated itself generation after generation with a fateful fidelity, his back to the world and his carven eyes gazing out across the valley where his railroad ran and the blue changeless hills beyond.

| *Flags in the Dust* |

The Carrara marble statue of Faulkner's great-grandfather Colonel William Clark Falkner in the Ripley Cemetery, Tippah County, Mississippi. Colonel Falkner had this statue commissioned before his death in 1889. By then he was an eminent figure in Mississippi, having been a lawyer, a daring officer in two wars, a noted author, a politician, and an entrepreneur, who had planned and developed the Ship Island, Ripley and Kentucky Railroad Company. Brave, ambitious, and public spirited, Colonel Falkner was also reckless, combative, and egocentric. He was the inspiration for Colonel John Sartoris in Faulkner's fiction as well as certain aspects of the characters Thomas Sutpen and L. Q. C. McCaslin.

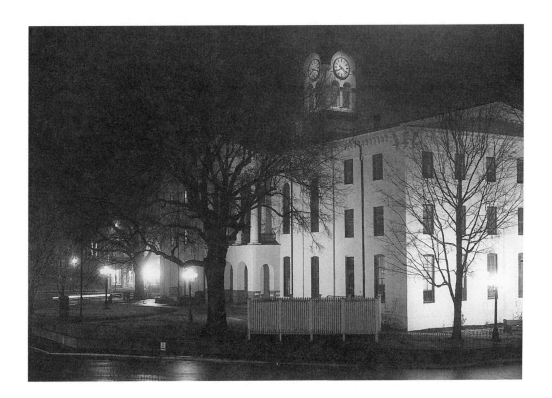

He could see the trees about the courthouse, and one wing of the building rising above the quiet and empty square. But people were not asleep. He could feel the wakefulness, the people awake about the town. . . .

He heard the clock strike twelve. Then—it might have been thirty minutes or maybe longer than that—he heard someone pass under the window, running. The runner's feet sounded louder than a horse, echoing across the empty square, the peaceful hours given to sleeping. It was not a sound Horace heard now; it was something in the air which the sound of the running feet died into.

When he went down the corridor toward the stairs he did not know he was running until he heard beyond a door a voice say, "Fire!"

| *Sanctuary* |

An evening view of Lafayette County Courthouse. Faulkner had a profound regard for this building's symbolic social value and the durability of its architecture and history. In the passage quoted above, Horace Benbow is probably looking out a window at the Holston House, a hotel that resembles the Oxford Inn or Butler Hotel, built by Jacob Thompson and managed by Faulkner's maternal great-grandparents Charles and Burlina Butler. After the Civil War it was refurbished and called the Thompson House—later the Majestic Hotel and then the Colonial Hotel. In 1920 Lemuel E. Oldham, Faulkner's future father-in-law sold this property to the First National Bank of Oxford. In spite of changing ownerships, it is still called the Thompson Building.

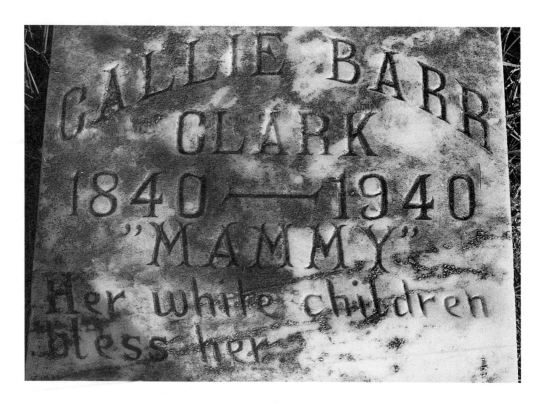

the woman who had been the only mother he, Edmonds, ever knew, who had raised him, fed him from her own breast as she was actually doing her own child, who had surrounded him always with care for his physical body and for his spirit too, teaching him his manners, behavior

| *Go Down, Moses* |

The gravestone for Caroline Barr, which Faulkner had placed in St. Peter's Cemetery. The inscription reads, "Her white children bless her." Born into slavery and freed at about age sixteen, "Mammy Callie," as she was called, served Faulkner and his mother's family for thirty-seven years. Because of her devotion and maternal feelings, the family viewed her as a second mother rather than as a servant. She was the inspiration for Dilsey Gibson in *The Sound and the Fury* and Molly Beauchamp in *Go Down, Moses*.

The street runs on ahead, where the square opens and the monument stands before the courthouse. We mount again while the heads turn with that expression which we know; save Jewel. He does not get on, even though the wagon has started again. "Get in, Jewel," I say. . . . But he does not get in. Instead he sets his foot on the turning hub of the rear wheel, one hand grasping the stanchion, and with the hub turning smoothly under his sole he lifts the other foot and squats there, staring straight ahead, motionless, lean, wooden-backed, as though carved.

| *As I Lay Dying* |

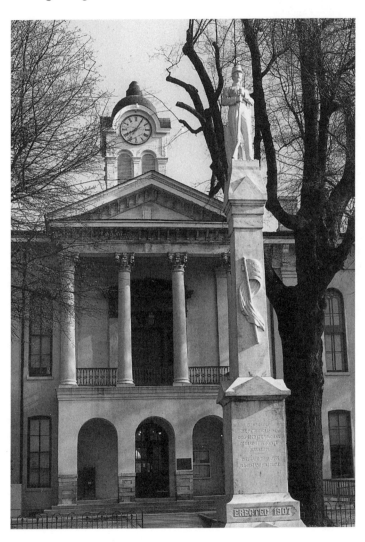

the courthouse centennial and serene above the town

| *Requiem for a Nun* |

Lafayette County Courthouse in Oxford. Built in 1840, it was burned during Federal occupation by General A. J. "Whiskey" Smith in 1864. When the courthouse was rebuilt ten years later, two balconies and four clocks on the sides of the cupola were added. In 1907 the United Daughters of the Confederacy (UDC) were responsible for the addition of the Confederate soldier monument facing south. This location appears often in Faulkner's fiction.

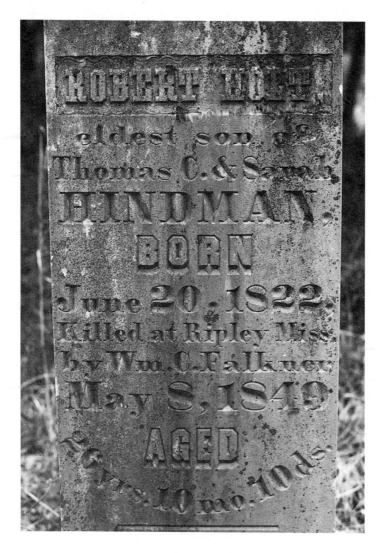

ROBERT HOLT
eldest son of
Thomas C. & Sarah
HINDMAN
BORN
June 20, 1822
Killed at Ripley Miss.
by Wm. C. Falkner
May 8, 1849
AGED
26 yrs. 10 mo. 10 ds.

he returned and I watched him clean the derringer and reload it and we learned that the dead man was almost a neighbor, a hill man . . . and we never to know if the man actually intended to rob Father or not because Father had shot too quick.

| *The Unvanquished* |

Gravestone for Robert Hindman in the Hindman family cemetery, Ripley, Mississippi. During his lifetime, Colonel William C. Falkner was respected by the citizens of Tippah County, but gradually his combative personality alienated him from several county leaders. Two years after Falkner served as an officer in the Mexican War, a private in his regiment, Robert Hindman, accused Falkner of personal misrepresentation and character slander. When Hindman attempted to shoot Falkner, the colonel stabbed the young man to death in self-defense. Although Falkner was acquitted by a jury, the Hindman family continued to claim that he had murdered their son.

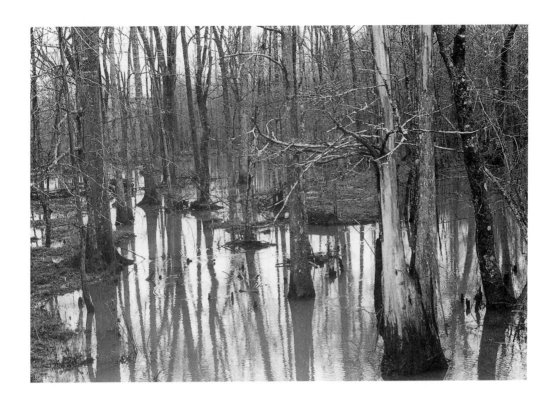

the thick, slow, black, unsunned streams almost without current, which once each year ceased to flow at all and then reversed, spreading, drowning the rich land and subsiding again, leaving it still richer | *Go Down, Moses* |

Yocona (Yoknapatawpha) River near the community of Tula in Lafayette County

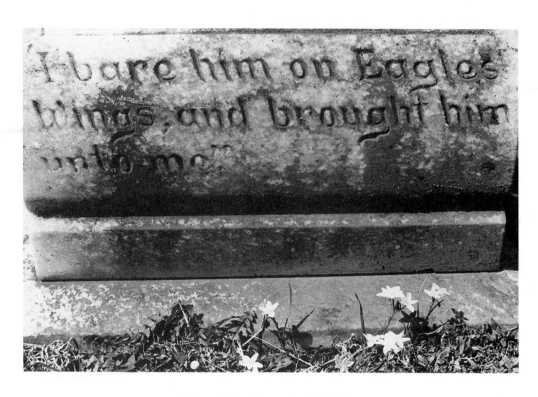

Lieut. John Sartoris, R.A.F.
Killed in action, July 5, 1918.
"I bare him on eagles' wings and brought him unto Me"

| *Flags in the Dust* |

Gravestone of Dean Falkner in St. Peter's Cemetery, Oxford. Like William Faulkner, his younger brother Dean was enthralled with flying. In November 1935 he was killed in the author's Cabin Waco during an air show in Pontotoc County, Mississippi. Dean's headstone bears the same inscription that Faulkner used eight years earlier to mark the grave of another young aviator, John Sartoris, in *Flags in the Dust*. The epitaph is a paraphrase of Exodus 19:4.

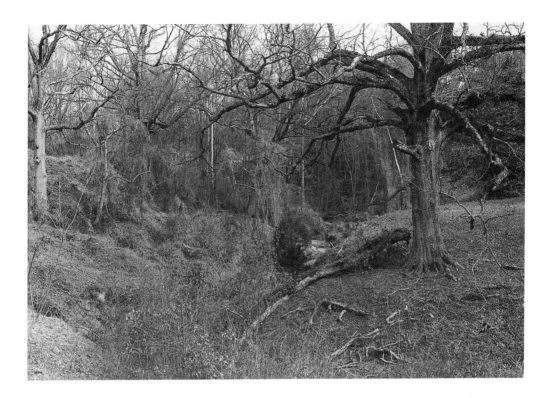

he could see the full span of the ravine. . . . Again from the town behind him the scream of the siren began to fall.

Then he saw Christmas. He saw the man, small with distance, appear up out of the ditch, his hands close together. As Grimm watched he saw the fugitive's hands glint once like the flash of a heliograph as the sun struck the handcuffs, and it seemed to him that even from here he could hear the panting and desperate breath of the man who even now was not free.

| *Light in August* |

The Big Ditch, a large gully or ravine a few hundred yards northwest of the Oxford town square, is now almost surrounded by houses and apartments. In early September 1908 a posse of white men and boys pursued Nelse Patton, a black man who had slashed a white woman's throat with a razor, and captured him in this ravine. Later, rallied by former senator William V. Sullivan, an angry mob ignored warnings from the judge and sheriff, broke into Patton's jail cell, shot him to death, and mutilated his corpse for public display. Faulkner, who was ten at the time, remembered the event and later transformed it into the dramatic crisis of *Light in August*. The characters Joe Christmas, Joanna Burden, and Percy Grimm have their roots in this lynching.

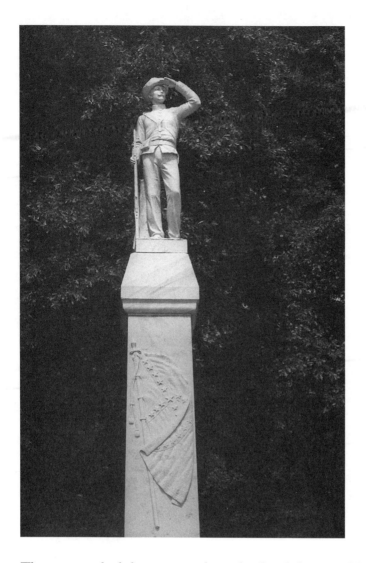

They approached the square, where the Confederate soldier gazed with empty eyes beneath his marble hand in wind and weather.

| *The Sound and the Fury* |

Confederate monument, University of Mississippi, Oxford. A majority of the members of the Lafayette County chapter of the United Daughters of the Confederacy (UDC) voted to erect this monument in memory of the University Greys, who were all killed or wounded in Pickett's Charge at Gettysburg, but a minority—led by the author's grandmother Sallie Murry Falkner—wanted it placed before the Oxford courthouse as a memorial to all Confederate soldiers. Sallie Falkner lost but then led a campaign supported by the United Confederate Veterans to erect the UDC monument that now stands before the courthouse. Perhaps in respect for his grandmother's wishes, Faulkner placed the university monument before his Jefferson courthouse in some of his novels.

The steamboat was still in our river, but it didn't go anywhere any more. Herman Basket told how one day during the high water, about three years after Doom went away, the steamboat came and crawled up on a sand-bar and died.

| "A Justice" |

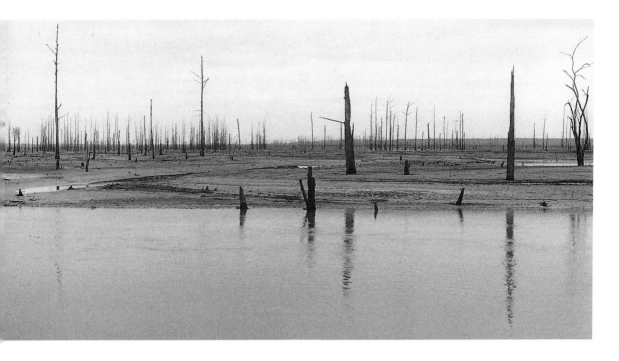

all that stretch of river-bottom which was a part of Thomas Sutpen's doomed baronial dream and the site of Major de Spain's hunting camp, is now a drainage district; the wilderness where Boon himself in his youth hunted . . . bear and deer and panther, is tame . . . now and even Wylie's Crossing is only a name.

| *The Reivers* |

View from the north side of Sardis Reservoir near the boat landing Wyatt Crossing, close to the town site of Old Wyatt. Here the Tallahatchie River has already begun its detour through Sardis Lake in the northern section of Lafayette County. During the nineteenth century this point was a terminus for riverboats. Faulkner spelled the name *Wyott* and changed it to *Wylie* in his later novels.

In the surrey with his cousin and Major de Spain and General Compson he saw the wilderness through a slow drizzle of November rain just above the ice point as it seemed to him later he always saw it or at least remembered it—the tall and endless wall of dense November woods under the dissolving afternoon and the year's death, sombre, impenetrable.

| *Go Down, Moses* |

Faulkner's Big Woods in late autumn, southeast Panola County, Mississippi. Several miles southwest of this scene General James Stone, like the character Major de Spain in "The Bear," had a deer-hunting camp in the Tallahatchie River bottomland. An immense and legendary bear called Old Reel Foot was hunted there. Stone's son Phil, a friend and mentor to young William Faulkner, introduced him to the camp in the fall of 1915.

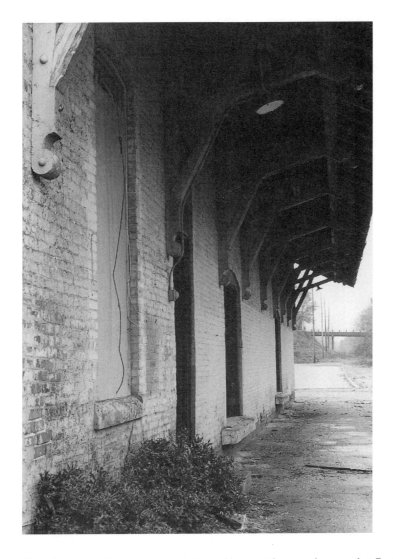

He had to get on the train to go to Jackson. I have not been on the train, but Darl has been on the train. Darl. Darl is my brother. Darl. Darl

| *As I Lay Dying* |

The old Oxford depot, virtually abandoned until its recent renovation, was a stopping place for Illinois Central Railroad passenger trains from 1872 until 1941, and its tracks accommodated occasional freight trains for another forty years. Serving the University of Mississippi campus as well as the town of Oxford, the station was located in Hilgard Cut, a passage dug by slaves before the Civil War for Mississippi Central Railroad access.

In *Sanctuary* Temple Drake, a coed at the university, takes the train south from the Oxford depot. In that book and in other Faulkner novels the station is also the Jefferson depot serving Colonel Sartoris's railroad. This photograph, taken about 1994, looks south beyond the depot and past Hilgard Cut in the direction Darl Bundren travels to the state asylum near Jackson and in the same direction the body of Joe Christmas is carried for burial in Mottstown (Water Valley, Yalobusha County).

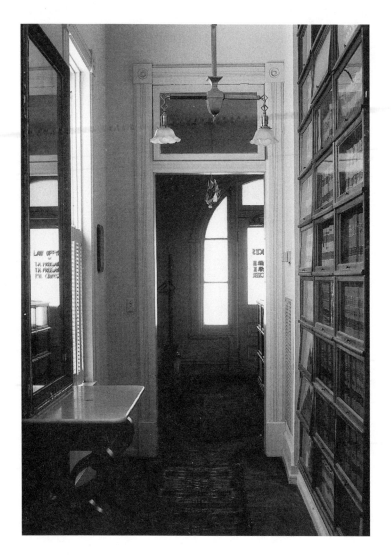

the same hot bright wind . . . blew into the office. . . . It fluttered among the county-attorney business on the desk and blew in the wild shock of prematurely white hair of the man who sat behind it—a thin, intelligent, unstable face, a rumpled linen suit from whose lapel a Phi Beta Kappa key dangled on a watch chain— Gavin Stevens, Phi Beta Kappa, Harvard, Ph.D., Heidelberg

| *Go Down, Moses* |

Hallway in the law offices of Freeland & Freeland, Oxford. The predecessor of Freeland & Freeland was James Stone & Sons, the law firm of Faulkner's friend Phil Stone. Used before the Civil War, this building at 1013 Jackson Avenue is the oldest law-office building in Mississippi. Before it was purchased by James Stone in 1905, it was the office of Senator William V. Sullivan and Justice L. Q. C. Lamar, who served with distinction on the United States Supreme Court from 1888 to 1892. The firm became James Stone & Sons after Phil Stone graduated from the Yale Law School in 1918. During his career Stone was best known as

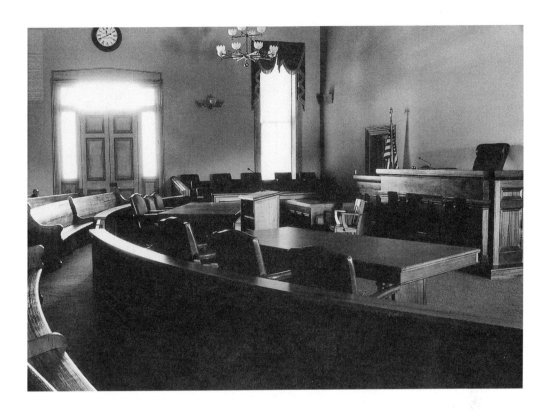

The air entered the open windows and blew over the heads and back to Horace in the door, laden with smells of tobacco and stale sweat and the earth and with that unmistakable odor of courtrooms; that musty odor of spent lusts and greeds and bickerings. . . . The windows gave upon balconies close under the arched porticoes. The breeze drew through them, bearing the chirp and coo of sparrows and pigeons that nested in the eaves, and now and then the sound of a motor horn from the square below.

| *Sanctuary* |

an appellate advocate. He was active in the Mississippi Bar and served as its president in 1948–49. Phil Stone was a model for Faulkner's Horace Benbow, and after 1930 the author had his friend in mind when he created the loquacious protagonist and county spokesman Gavin Stevens, a lawyer who appears frequently in the stories and novels through *The Mansion* (1959).

(*above*) View of the courtroom in Lafayette County Courthouse, Oxford

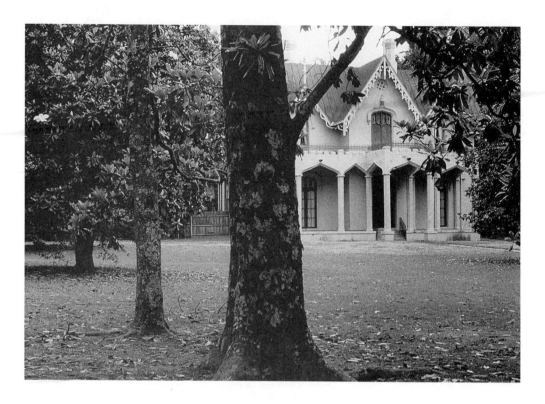

the street opened away between old shady lawns, spacious and quiet. These homes were quite old . . . and, set well back from the street and its dust, they emanated a gracious and benign peace, steadfast as a windless afternoon in a world without motion or sound.

| *Flags in the Dust* |

Two examples of antebellum architecture that Faulkner admired. Airliewood in Holly Springs, Marshall County, Mississippi, is a Tudor–Gothic Revival villa based on designs by the noted Philadelphia architect Samuel Sloan. The house was built in 1858 for the planter Will Henry Coxe. General Ulysses S. Grant used this mansion as a military headquarters while his Federal troops occupied Holly Springs in December 1862. Holly Springs, about twenty-nine miles north of Oxford, is similar to the university town in its history and its civic and domestic architecture. In these aspects Holly Springs resembles Jefferson in *Light in*

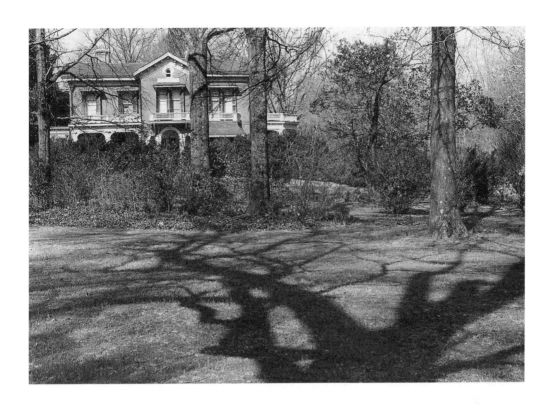

August—as does Oxford. Ammadelle, an Italianate mansion, was built in Oxford about 1860 for Thomas E. B. Pegues, a prosperous owner of nearly three thousand acres in nearby Woodson's Ridge. It is a noteworthy example of the architectural and landscape planning of Calvert Vaux (1824–1895), one of the designers of Central Park in New York City. Vaux is obviously the fabled French architect who is mentioned in several Faulkner novels, remembered for his planning of Sutpen's Hundred while in sub-jugation. Ammadelle is similar to the Benbow house in *Flags in the Dust*.

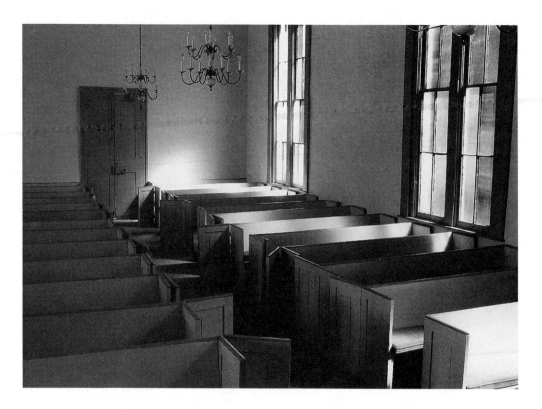

The powder was to hide the mark of tears. But before the wedding was over the powder was streaked again, caked and channeled. Ellen seems to have entered the church that night out of weeping as though out of rain, gone through the ceremony and then walked back out of the church and into the weeping again. . . .

It was the wedding which caused the tears: not marrying Sutpen. Whatever tears there were for that, granted there were tears, came later. | *Absalom, Absalom!* |

An interior view of College Church, or College Hill Presbyterian Church, built in 1845 near the community of College Hill, about six miles northwest of Oxford. In *Absalom, Absalom!* Sutpen's marriage (June 1838) to Ellen Coldfield takes place in the Methodist Church in Jefferson, but the map of Yoknapatawpha County Faulkner drew for that novel locates the "church which Thomas Sutpen rode fast to" for his wedding about four miles northwest of Jefferson, a location coinciding with that of College Church. This church should have had a parallel biographical significance for Faulkner because it was the location for his wedding to Estelle Oldham Franklin in June 1929. He may also have been thinking of College Church, which once had a slave balcony, when he described the rural Episcopal church with a slave gallery that Colonel Sartoris's family attends in *The Unvanquished* (see "Riposte in Tertio").

I walked steadily on enclosed in the now fierce odor of the verbena sprig. . . . I did not pause, I looked once at the small faded sign nailed to the brick *B.J. Redmond. Atty at Law* and began to mount the stairs, the wooden steps scuffed by the heavy bewildered boots of countrymen approaching litigation and stained by tobacco spit, on down the dim corridor to the door.

| *The Unvanquished* |

At the northwest corner building on Oxford's town square, stairs ascend to a second-floor gallery off which Faulkner's uncle John Wesley Thompson Falkner II (1882–1962) had his law office for more than forty years. This building served as the Oxford City Hall and Federal Court from about 1868 until 1886. Although the last chapter or story "An Odor of Verbena" in *The Unvanquished* is set in about 1874, Faulkner probably had his uncle's office in mind for Bayard Sartoris's rendezvous with Ben Redmond, his father's assassin.

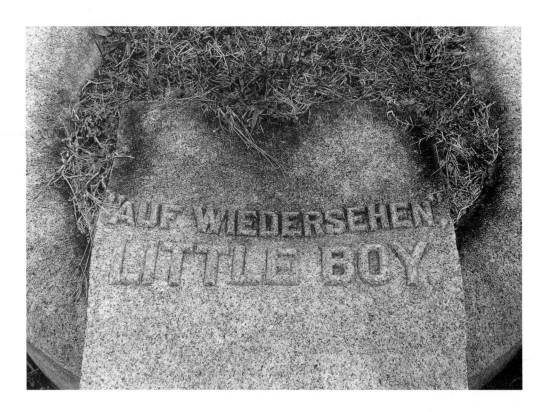

Auf Wiedersehen, Little Boy. He continued to smooth, to stroke the letters after the earth was gone. . . . "You see, if I could believe that I shall see and touch him again, I shall not have lost him. . . . Because I am I through bereavement and because of it. I do not know what I was nor what I shall be. But because of death, I know that I am. . . . To lie beside him will be sufficient for me."

| "Beyond" |

Estelle Faulkner had a younger brother, Ned, who died of rheumatic fever at age nine. His grave in the Oldham family plot on the southern edge of St. Peter's Cemetery is marked by a small monument inscribed with his name and dates: "Edward de Graffenreid Oldham, 1907–1916," and at its foot a smaller stone bears the words "Auf Wiedersehen Little Boy." The Judge, the bereaved father in the story "Beyond," is similar to Ned's father, Lemuel Oldham.

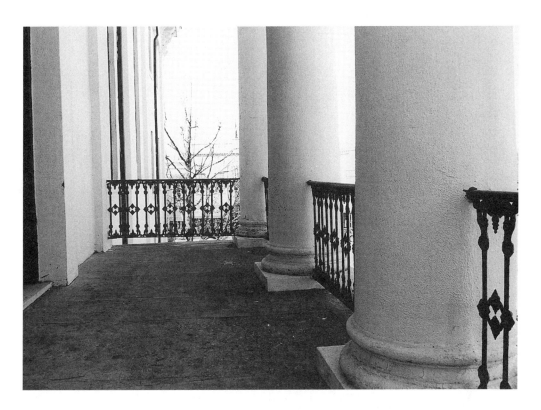

two identical four-column porticoes, one on the north and one on the south, each with its balcony of wrought-iron New Orleans grillwork, on one of which— the south one—in 1861 Sartoris would stand in the first Confederate uniform the town had ever seen, while in the Square below the Richmond mustering officer enrolled and swore in the regiment which Sartoris as its colonel would take to Virginia

| *Requiem for a Nun* |

Faulkner admired the balconies of Marshall County Courthouse in Holly Springs, which are similar in design to the Lafayette County Courthouse balcony pictured here. Though he depicted Colonel Sartoris on such a balcony at the outbreak of the Civil War, neither courthouse had balconies until being rebuilt during Reconstruction.

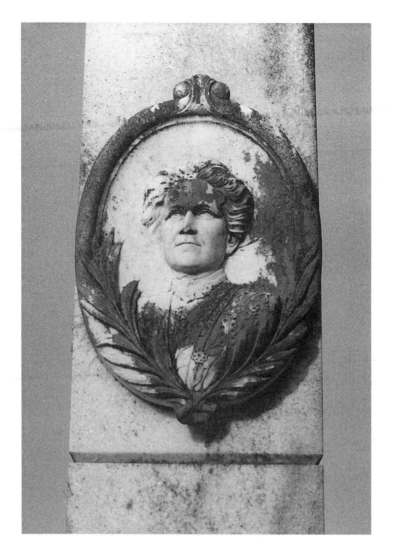

It was him—Lawyer—that helped Linda hunt through that house and her mother's things until they found the right photograph and had it—Lawyer still—enlarged, the face part, and sent it to Italy to be carved into a . . . yes, medallion to fasten onto the front of the monument, and him that the practice drawings would come back to. . . . But it was Flem's monument; dont make no mistake about that. It was Flem that paid for it, first thought of it, planned and designed it, picked out what size and what was to be wrote on it.

| *The Town* |

Monument to Sallie Murry Falkner in St. Peter's Cemetery, Oxford. Faulkner used his paternal grand-mother's marble monument and part of its inscription, "Her children arise and call her blessed," to honor the tragic Eula Varner Snopes. Sallie Murry Falkner should not be confused with Lelia Butler, the author's maternal grandmother, who was the probable source for Damuddy in *The Sound and the Fury*.

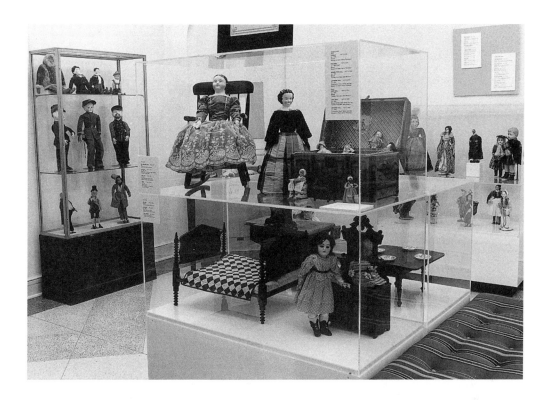

There was an old lady born and raised in Jefferson who died rich somewhere in the North and left some money to the town to build a museum with. It was a house like a church, built for nothing else except to hold the pictures she picked out to put in it—pictures from all over the United States, painted by people who loved what they had seen or where they had been born or lived enough to want to paint pictures of it so that other people could see it too. . . . people like us from Frenchman's Bend . . . could come without charge into the cool and the quiet and look without let at the pictures of men and women and children who were the same people that we were.

| "Shall Not Perish" |

A doll exhibit in the Mary Buie Museum (University of Mississippi Museums). Mary Skipwith was born and raised in Oxford. During her marriage to Henry T. Buie, she lived in Chicago and was employed as an artist and decorator in several department stores. When she died in 1937, she left thirty thousand dollars for a small museum to house her artwork and family collection of antiques and manuscripts. Two years later the Mary Buie Museum was opened in Oxford with a larger collection of decorative art, fine art, and historical memorabilia relating to Oxford and the Skipworth family, who—along with government agencies—financed the museum's development. Until 1974 the museum's collection expanded to include historic costumes, dolls, and Civil War relics; subsequently the City of Oxford transferred ownership of the museum to the University of Mississippi. In the 1950s Faulkner gave his Nobel Prize award plaque to the museum, which also includes in its collections a few oil paintings by his mother, Maud Falkner.

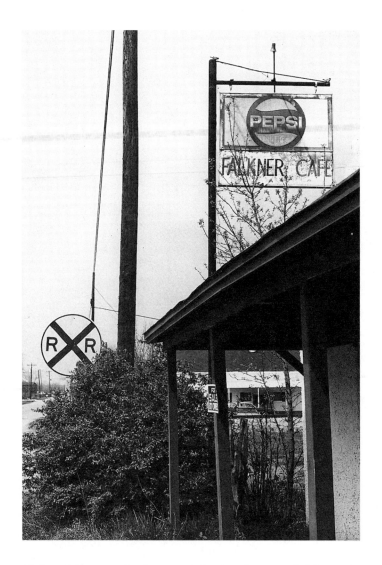

Colonel Sartoris had opened the local cottonfields to Europe by building his connecting line up to the main railroad from Memphis to the Atlantic Ocean—narrow gauge, like a toy, with three tiny locomotives like toys too, named after Colonel Sartoris's three daughters, each with its silver-plated oilcan engraved with the daughter's christian name.

| "Mississippi" |

Railroad crossing in the town of Falkner, Tippah County. By 1888 Colonel W. C. Falkner's Ship Island, Ripley and Kentucky Railroad was approaching the crest of its success, traveling from Middleton, Tennessee, to Pontotoc, Mississippi, a distance of more than sixty miles. The colonel named the two locomotives the *General M. P. Lowrey* and the *Colonel W. C. Falkner,* and he called the new depot stops along the way Falkner, Guyton, Ingomar, and Ecru. After the colonel's death in 1889, the Falkner family renamed the line the Gulf and Chicago Railroad. It remained a "doodlebug" railroad traveling on narrow-gauge rails until the family sold it in 1903 to the Mobile, Jackson and Kansas City Railroad, which converted it to standard gauge. Except for the tracks from Ripley to New Albany in Union County, currently used by the Mississippi Tennessee Railroad, the remaining rails were disposed of after 2005.

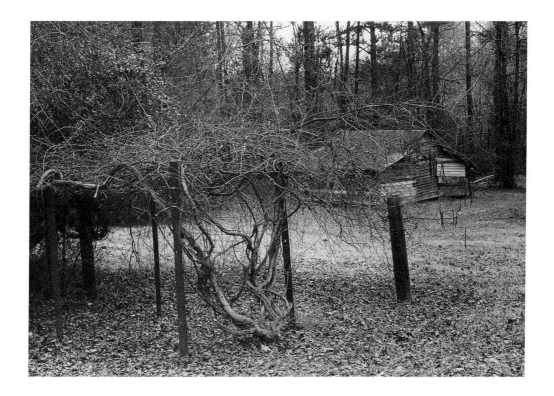

he was gone now, the foreigner, the Frenchman, with his family and his slaves and his magnificence. His dream, his broad acres were parceled out now into small shiftless mortgaged farms. . . . his legend but the stubborn tale of the money he buried somewhere about the place when Grant over-ran the country on his way to Vicksburg.

| *The Hamlet* |

A view from Thomas Gore's grave site in Calhoun City, forty miles south of Oxford. Throughout rural America there were stories of money buried on the abandoned land of prosperous owners long deceased. Faulkner may have heard some of these rumors in his native counties. When he wrote "Lizards in Jamshyd's Courtyard" (1930), a story concerned with the search for buried money, he may also have known about a particular legend that was later recounted in *Mississippi: the WPA Guide* (1938). According to the Calhoun County Historical Society, the town of Calhoun City was settled on about 640 acres owned by Thomas T. Gore. Before his death in 1855, The WPA guide says that "Gore buried a great part of the gold he had amassed on his plantation, and died without revealing its hiding place. Hopeful persons still dig diligently near the plantation in search of the treasure."

Soon now they would enter the Delta. The sensation was familiar to him. It had been renewed like this each last week in November for more than fifty years—the last hill, at the foot of which the rich unbroken alluvial flatness began as the sea began at the base of its cliffs, dissolving away.

| *Go Down, Moses* |

A distant view in late November of the Mississippi Delta before the road descends westward from the hill country in Tallahatchie County near the community of Cascilla, about sixty-eight miles southwest of Oxford. Faulkner may have had in mind the descent from the hills of Tallahatchie County farther north on what is now Highway 32 near Charleston, the probable route taken by his hunters from Jefferson to Major de Spain's camp; but the descent there is now so gradual that the contrast in elevation is not very striking. This diminished perspective is caused by the widening of the highway and the grading of road shoulders. Road grading has also diminished the deep, rolling vistas of Highway 6 as one travels over the eastern ridges of Lafayette County from Pontotoc County. Old Highways 334 or 336, which parallel Highway 6, may have provided a similar view to the one that mesmerized Lena Grove—motion and time and space suspended in heat—on her way to Jefferson in *Light in August*.

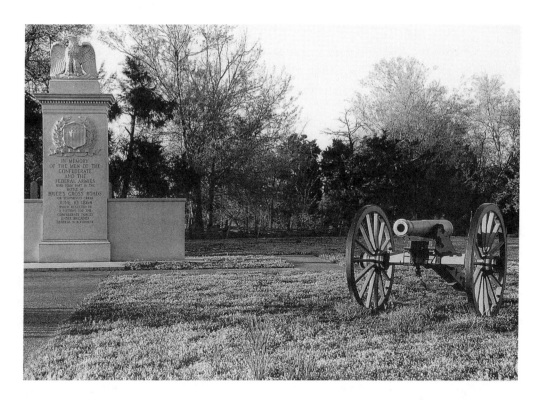

"Genl Fawhrest say he respectful compliments," Lucius said, "and he can't come to breakfast this morning because he gonter to be whuppin Genl Smith at Talla-hatchie Crossing about that time. But providin he ain't too fur away in the wrong direction when him and Genl Smith git done, he be proud to accept your invita-tion next time he in the neighborhood."

| "My Grandmother Millard and
General Bedford Forrest and
the Battle of Harrykin Creek" |

Memorial to the fallen at Brice's Crossroads and the battleground beyond, Lee County, Mississippi. Nathan Bedford Forrest (1821–1877) was promoted to brigadier general in 1862 and given command of a Confederate cavalry brigade. He soon became known for his innovative use of guerrilla tactics in cavalry attacks. Forrest tried to harass the enemy with fast-moving raids, cutting off rearguard support, and disrupting supply trains and Federal communications by destroying railroad tracks and severing tele-graph lines. It is said that he drove the Union generals Ulysses S. Grant and William T. Sherman to fits of anger. Forrest's major victory came on June 10, 1864, when his outnumbered thirty-five-hundred men clashed with eight thousand Federal soldiers commanded by General Samuel D. Sturgis in the Battle of Brice's Crossroads, or Tishomingo Creek, thirty-five miles southeast of Ripley. Forrest used his knowledge of the enemy, aggressive tactics, extreme summer heat, and a marshy terrain to win the most decisive victory for the Confederacy in the western theater of the Civil War.

It was that country. Flat and rich and foul, so that the very winds seem to engender money out of it. . . . That Delta. Five thousand square miles, without any hill save the bumps of dirt the Indians made to stand on when the River overflowed.

| *Sanctuary* |

This Delta, he thought: This Delta. This land which man has deswamped and denuded and derivered in two generations . . . where cotton is planted and grows man-tall in the very cracks of the sidewalks, and usury and mortgage and bankruptcy and measureless wealth.

| *Go Down, Moses* |

Mississippi Delta cotton fields, Tallahatchie County

You cant do no good looking through the gate, T.P. said. Miss Caddy done gone long ways away. Done got married and left you. You cant do no good holding to the gate and crying. She cant hear you.

| *The Sound and the Fury* |

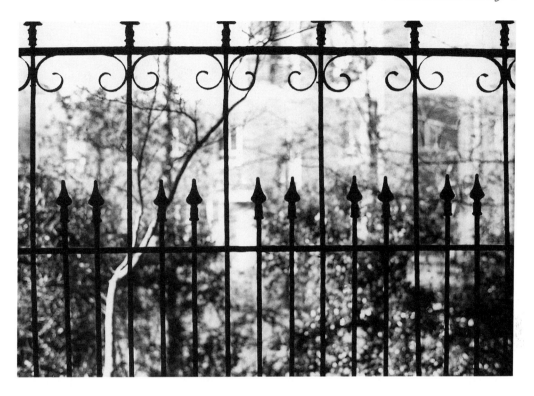

"He wont hurt you. I pass here every day. He just runs along the fence."

They came on. I opened the gate and they stopped, turning. I was trying to say, and I caught her, trying to say, and she screamed and I was trying to say and trying and the bright shapes began to stop and I tried to get out . . . the bright shapes were going again. They were going up the hill to where it fell away and I tried to cry. But when I breathed in, I couldn't breathe out again to cry.

| *The Sound and the Fury* |

At the Thompson-Chandler house in Oxford, a large, ornate iron fence once enclosed the yard where Edwin Chandler (Benjy Compson) was confined. Several years ago it was disassembled and moved to Vicksburg. The fence in this photograph is a section of the wrought-iron fence that Colonel W. C. Falkner had installed at his new house in 1884. The house was dismantled by 1937, when a new Ripley Post Office was built on that site. Librarian Tommy Covington recovered this section and a double fence gate for the Ripley Public Library some time after 1988. He has recently given these objects to the Tippah County Historical Museum.

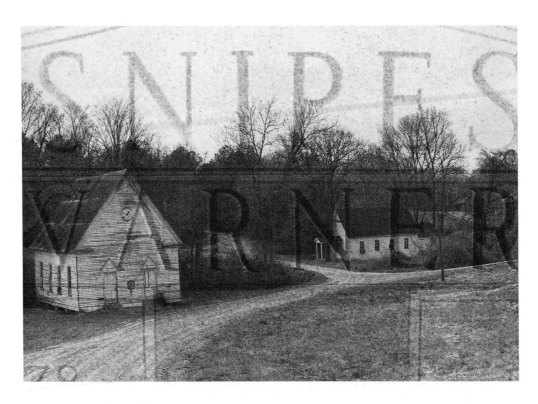

he turned and saw, silhouetted by the open door, a man smaller than common, in a wide hat and a frock coat too large for him, standing with a curious planted stiffness. "You Varner?" the man said, in a voice . . . rusty from infrequent use.

"I'm one Varner," Jody said, in his bland hard quite pleasant voice. "What can I do for you?"

"My name is Snopes. I heard you got a farm to rent."

"That so?" Varner said, already moving so as to bring the other's face into the light. "Just where did you hear that?" . . .

The other did not answer. Now Varner could see his face—a pair of eyes of a cold opaque gray.

| *The Hamlet* |

Montage juxtaposing two dominate names in *The Hamlet* and the village of Enid in Tallahatchie County. Several family names in Faulkner's fiction may be found in Lafayette County cemeteries, including Varner, De Spain, Bundren, Bunch, Hightower, Littlejohn, Snipes (similar to Snopes), Carruthers, Buffaloe, Shegog, Suratt, Grimm, Stevens, and of course Jones. Although it is easy to identify Jefferson's fictional counterpart as Oxford, and to a lesser degree Ripley and Holly Springs, it is more difficult to locate the Lafayette County village that resembles the fictional Frenchman's Bend or Varner's Crossroads. Taylor, with its close proximity to the old Jones and Shipp country mansions (the latter certainly resembling the Old Frenchman place) might have been the model for Frenchman's Bend. The communities of Tula and particularly Dallas and Paris could also be strong choices because of their past reputations for violence, their seclusion, and their close location to the hamlet on Faulkner's maps of Yoknapatawpha, but none of these communities now resembles Frenchman's Bend. The tiny, remote village of Enid in neighboring Tallahatchie County is quite similar to Frenchman's Bend in appearance.

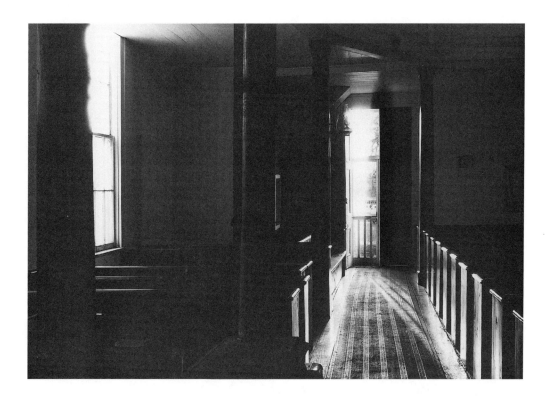

in the middle of a hymn, there had come a tremendous noise from the rear of the church, and turning the congregation saw a man standing in the door. . . . the sound crashed into the blended voices like a pistol shot. Then the man came swiftly up the aisle . . . toward the pulpit where the preacher leaned, his hands still raised, his mouth still open. Then they saw that the man was white. In the thick, cavelike gloom which the two oil lamps but served to increase, they could not tell at once what he was until he was halfway up the aisle. Then they saw that his face was not black, and a woman began to shriek, and people in the rear sprang up and began to run toward the door.

| *Light in August* |

Interior of a country church, Lafayette County

a dim hot airless room with the blinds all closed and fastened for forty-three summers . . . and which (as the sun shone fuller and fuller on that side of the house) became latticed with yellow slashes full of dust motes which Quentin thought of as being flecks of the dead old dried paint itself blown inward from the scaling blinds as wind might have blown them. There was a wisteria vine blooming for the second time that summer on a wooden trellis before one window, into which sparrows came now and then in random gusts, making a dry vivid dusty sound.

| *Absalom, Absalom!* |

Exterior wall and window of an old house in Oxford.

you know again now that there is no time: no space: no distance: a fragile and workless scratching almost depthless in a sheet of old barely transparent glass, and (all you had to do was look at it a while; all you have to do now is remember it) there is the clear undistanced voice . . . from the long long time ago: *"Listen, stranger; this was myself: this was I."*

| *Requiem for a Nun* |

"Jennie Garland," inscription on glass (University of Mississippi Museums). Faulkner's image of the young woman scratching her name, "Cecilia Farmer," on a windowpane with her diamond ring was to him an assertion of identity in the face of oblivion. The existence of three known examples from in and near Lafayette County suggests that this practice may have been a fashion for young, engaged women, particularly during the Civil War era.

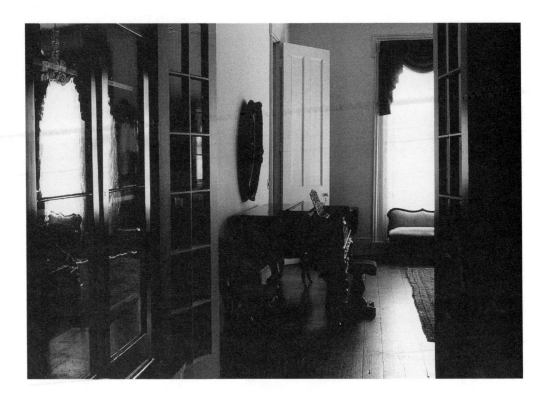

Light came through the open door, but the windows were shuttered behind heavy maroon curtains, and it served only to enhance the obscurity . . . and in all the corners of the room there waited . . . figures in crinoline and hooped muslin and silk; in stocks and flowing coats; in gray too, with crimson sashes and sabres in gallant sheathed repose;—Jeb Stuart himself perhaps . . . Miss Jenny sat with her uncompromising grenadier's back and held her hat upon her knees and fixed herself to look on as her guest touched chords from the keyboard and wove them together and rolled the curtain back upon the scene.

| *Flags in the Dust* |

Parlor at Cedar Oaks, Oxford. Cedar Oaks was built as the personal residence of the architect William Turner in 1859. His sister Mary Orr saved the house from being burned by Federal troops in 1864, and it was moved to its present location and renovated by 1964. This Greek Revival house is similar in style to at least five other mansions in antebellum Oxford that were either built by or influenced by Turner: the Neilson-Culley House, the Carter-Tate House, the Shegog House (Faulkner's Rowan Oak), the Thompson-Chandler House, and the Howry-Wright House.

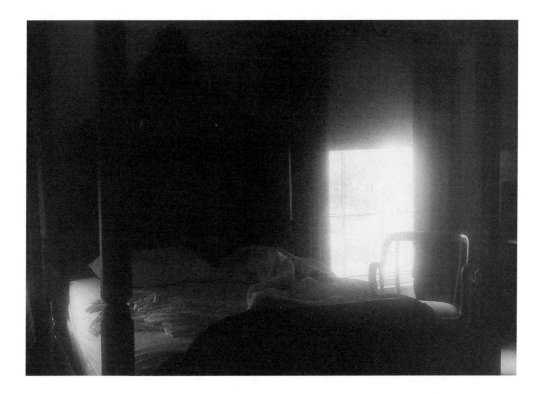

we knew that there was one room in that region above stairs which no one had seen in forty years, and which would have to be forced. . . . The violence of breaking down the door seemed to fill this room with pervading dust. A thin, acrid pall of the tomb seemed to lie everywhere upon this room decked and furnished as for a bridal: upon the valance curtains of faded rose color.

| "A Rose for Emily" |

Upstairs bedroom in the Neilson-Culley House, a private residence in Oxford (photographed by kind permission of William Lewis, Jr., the present owner). About 1927, two years before Faulkner wrote "A Rose for Emily," the streets of Oxford were paved by the W. G. Lassiter Company. A popular company foreman, Captain Jack Hume from New England, courted Mary Louise Neilson, a granddaughter of William S. Neilson, founder of Oxford's oldest department store. Her socially prominent and widowed father objected to the marriage of his middle-aged, genteel daughter to an outsider, a laborer from the North. Nevertheless Miss Mary Louise and Capt' Jack did marry and spent the remainder of their lives in Oxford. He did not leave her as Homer Barron jilts Emily Grierson in Faulkner's gothic tale—a fate similar to Miss Havisham's in *Great Expectations*. (Faulkner was an admirer of Dickens.)

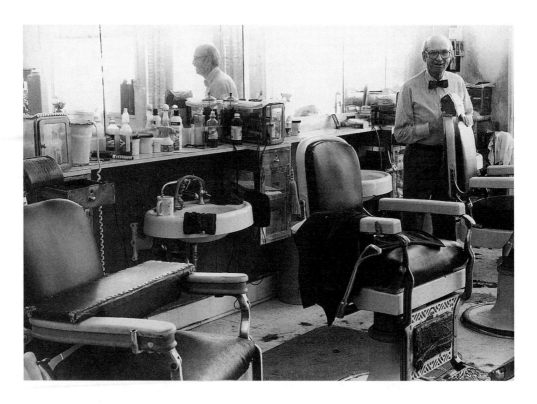

A little, sandy-complected man with a face you would not remember . . . in a blue serge suit and a black bow tie, the kind that snaps together in the back, that you buy already tied in the store. Maxey told me he was still wearing that serge suit and tie when he got off the south-bound train in Jefferson a year later, carrying one of these imitation leather suitcases. And when I saw him again in Jefferson in the next year, behind a chair in Maxey's shop, if it had not been for the chair I wouldn't have recognized him at all. Same face, same tie; be damned if it wasn't like they had picked him up, chair, customer and all, and set him down sixty miles away without him missing a lick.

| "Hair" |

Interior view of Parks' Barbershop on Jackson Avenue near the Oxford town square. The photograph was taken in 1991, a few years before the shop closed. The barber wearing a black bow tie (fact imitating fiction) was Mr. Ernest Oliver, who began cutting hair in the shop in 1941. Faulkner's character, Hawkshaw the barber, appears in "Dry September" and "Hair," both published in 1930.

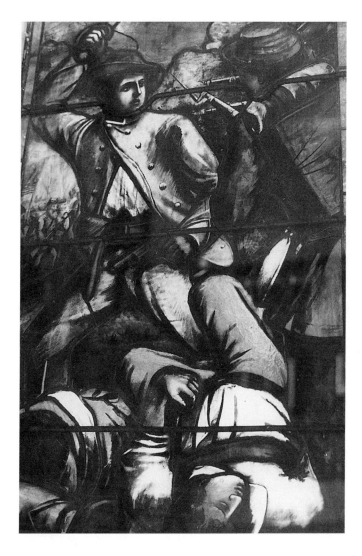

For every Southern boy fourteen years old, not once but whenever he wants it, there is the instant when it's still not yet two oclock on that July afternoon in 1863, the brigades are in position behind the rail fence, the guns are laid and ready in the woods and the furled flags are already loosened to break out and Pickett . . . looking up the hill waiting for Longstreet to give the word and it's all in the balance, it hasn't happened yet, it hasn't even begun yet.

| *Intruder in the Dust* |

Memorial window in Ventress Hall, University of Mississippi. Built in 1889, Ventress Hall has on its central staircase a large stained-glass window commissioned from the Tiffany Company primarily to honor the University Greys, a company of the university's students that suffered total casualties during the Battle of Gettysburg, but also to honor all its faculty and students who fought for the Confederate cause. Faulkner was familiar with this building as a handyman, student, and postmaster while living with his parents on campus during the 1920s.

to me
Who marble-bound must ever be
While turn unchangingly the years.
My heart is full, yet sheds no tears
To cool my burning carven eyes

| *The Marble Faun* |

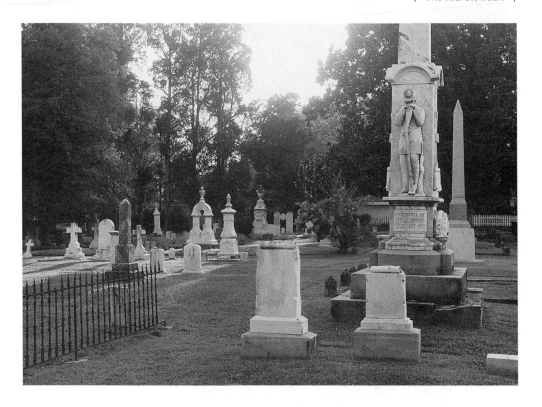

And now Miss Emily had gone to join the representatives of those august names
where they lay in the cedar-bemused cemetery among the . . . graves of Union
and Confederate soldiers who fell at the battle of Jefferson.

| "A Rose for Emily" |

Twilight view of Hillcrest Cemetery in Holly Springs. The monument in the foreground is dedicated "in
memory of Marshall County's Confederate dead," and nearby are the graves of several Confederate gen-
erals and other officers. As in his elegiac short story "Sepulture South: Gaslight," cemetery statues repre-
sented to Faulkner an ironic comparison of the peaceful dead to the anguish and travail of the living.

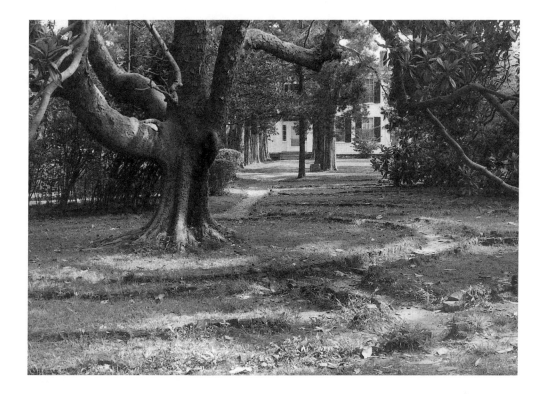

it had been the original grant and site of a tremendous pre—Civil War plantation, the ruins of which—the gutted shell of an enormous house with its fallen stables and slave quarters and overgrown gardens and brick terraces and promenades— were still known as the Old Frenchman place.

| *The Hamlet* |

The concentric garden at Rowan Oak, Oxford. Faulkner probably based the Old Frenchman place on the Old Shipp place near the village of Taylor, seven miles south of Oxford. Dr. Felix Grundy Shipp obtained his Lafayette County property at the Pontotoc land auctions during the 1830s. About 1857 he built an impressive Greek Revival plantation house with attractive gardens. After his daughter's death in the early 1920s, the property was abandoned. The rooms were plundered for possible heirlooms, and the gardens were taken over by undergrowth. The decaying house fell apart about 1971. William Turner may have designed Dr. Shipp's house, and he certainly was the architect for several mansions in Oxford. One of these is the Shegog-Faulkner House, built in 1848 for Colonel Robert R. Shegog. When Faulkner bought the house in 1930, it had deteriorated. Renaming it Rowan Oak, he gradually restored and expanded the property, making it his family home until 1962. Created during the 1850s, the concentric garden at Rowan Oak consisted of a circle of cedar trees enclosing raised brick beds around a magnolia tree.

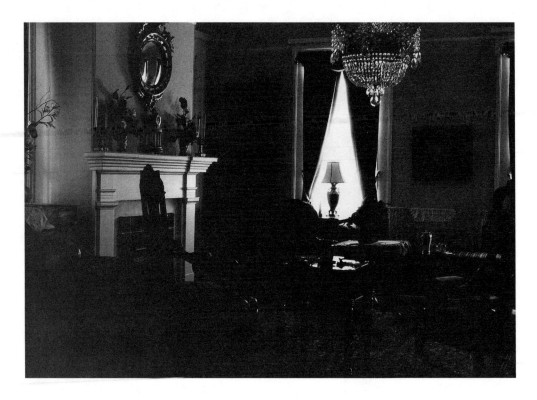

Time and its furniture

Flags in the Dust

Parlor at Lochinvar, Pontotoc County. In 1836 the Scotsman Robert Gordon (1788–1867) built Lochinvar, one of the most stately mansions in north Mississippi. He had arrived about 1810, establishing himself as a successful merchant in the Black Prairie area, near the town of Aberdeen, which he founded and named. With the Treaty of Pontotoc Creek (1832), the federal government dispersed six million acres of the Chickasaws' land, and Gordon, being a witness to the treaty, was able to acquire three hundred thousand acres in the hill country of Pontotoc County, about thirty-five miles east of Oxford. Here he built Lochinvar. Designed in the Greek Revival style by a Scottish architect using heart-pine lumber and handmade bricks, it was furnished with chandeliers and beautiful objects from Europe. According to legend the columns for the two-story front portico were shipped from Scotland to Mobile and carted overland by oxen. Gordon's son James inherited the property and later lost it to foreclosure. From 1900 to 1926 the mansion was abused by tenant farmers and bootleggers. Since 1966 Drs. Forrest T. and Janice B. Tutor have restored the house and grounds. Readers of Faulkner may see interesting parallels with Lochinvar's history and Sutpen's Hundred in *Absalom, Absalom!* and the Old Frenchman place, particularly in *Sanctuary*.

46

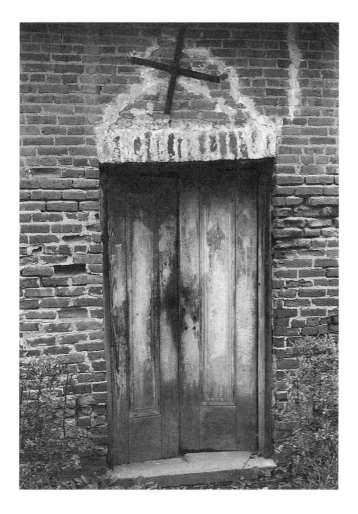

covering the next five pages and almost that many years, the slow, day-by-day accrument of the wages allowed him and the food and clothing—the molasses and meat and meal, the cheap durable shirts and jeans and shoes and now and then a coat against rain and cold—charged against the slowly yet steadily mounting sum of balance (and it would seem to the boy that he could actually see the black man, the slave . . . asking permission perhaps of the white man's son to see the ledger-page which he could not even read . . .) on to the double pen-stroke closing the final entry:

3 Nov 1841 By Cash to Thucydus McCaslin $200. dolars Set Up blaksmith in J. Dec 1841 Dide and burid in J. 17 feb 1854

Eunice Bought by Father in New Orleans 1807 $650. dolars. Marrid to Thucydus 1809 Drownd in Crick Cristmas Day 1832.

| *Go Down, Moses* |

This small building was a kitchen built for the Shegog House during the late 1840s. Built from bricks fired on the property, it is one of very few remaining structures in north Mississippi whose appearance at the time of this photograph (1990) might suggest a slave quarter. Faulkner used this kitchen as a smokehouse.

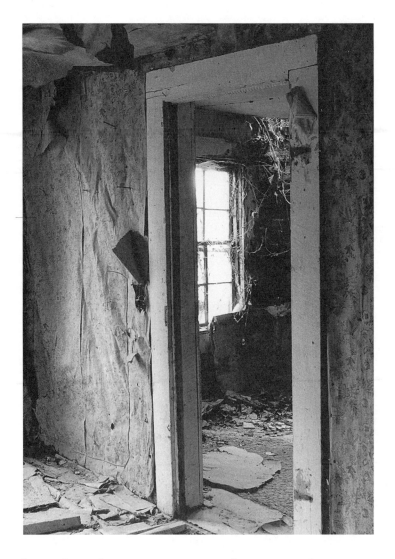

he paid rent but not taxes, paying almost as much in rent in one year as the house had cost to build; not old, yet the roof of which already leaked and the weather-stripping had already begun to rot away from the wall planks and which was just like the one he had been born in which had not belonged to his father either.

| *The Hamlet* |

A ruined tenant-cabin interior on, or very near, the 320 acres of Greenfield Farm, seventeen miles northeast of Oxford, which Faulkner bought in 1938 so that he and his brother John could farm. Since their deaths, demarcations for the property have disappeared, and—except for overgrown fields and woods—little remains. Ownership of this land provided Faulkner with a better understanding of remote rural life in the hills of Beat Two for his fiction.

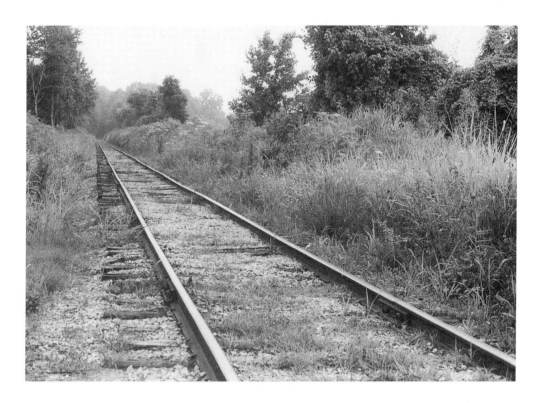

The train is beginning to increase its speed; he watches the approach of the car where Brown vanished. It passes; clinging to the rear of it, between it and the next car, Brown stands, his face leaned out and watching the bushes. They see one another at the same moment: the two faces, the mild nondescript, bloody one and the lean, harried, desperate one contorted now in a soundless shouting above the noise of the train, passing one another as though on opposite orbits and with an effect as of phantoms or apparitions.

| *Light in August* |

Railroad tracks near Walnut, Mississippi. These standard gauge tracks, recently removed, were laid by the Mobile, Jackson and Kansas City Railroad, replacing Colonel Falkner's narrow-gauge railroad in 1903. This photograph shows the route his train ran from north Tippah County toward Tennessee.

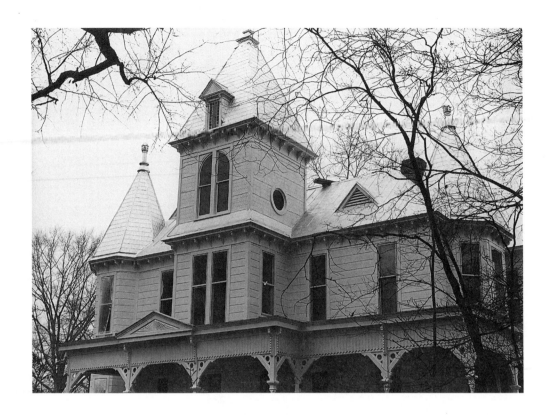

decorated with cupolas and spires and scrolled balconies . . . set on what had once been our most select street. But garages and cotton gins had encroached and obliterated even the august names of that neighborhood; only Miss Emily's house was left.

| "A Rose for Emily" |

The Augustus A. Smith house, Oxford. Built about 1903, this house on South Lamar Avenue appears similar to Emily Grierson's house with its gothic turrets and scrollwork, but the Grierson house is about thirty years older and more imposing. It is also possible that the author had in mind the Neilson house, which "fell in the twentieth century into picturesque ruin," according to Thomas S. Hines, before Dr. John C. Culley restored it to its present elegance.

some of us had never seen the mound, yet all of us had heard of it, talked of it as boys will. It was as much a part of our lives and background as the land itself, as the lost Civil War.

| "A Bear Hunt" |

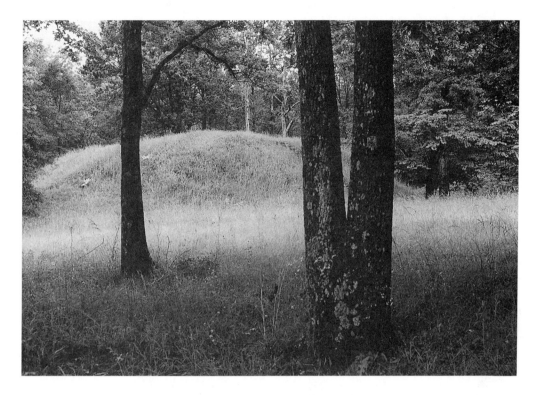

in the beginning the predecessors crept with their simple artifacts, and built the mounds and vanished, bequeathing only the mounds in which the succeeding recordable Algonquian stock would leave the skulls of their warriors and chiefs and babies and slain bears, and the shards of pots, and hammer- and arrow-heads and now and then a heavy silver Spanish spur.

| "Mississippi" |

Owl Creek Mounds, an eight-hundred-year-old ceremonial site in Chickasaw County, Mississippi. Indian mound building was prevalent across the southeastern United States during the Mississippian period (1000–1700 C.E.). Most mounds of this period were rectangular, flat-topped earthen platforms on which temples or the dwellings of chiefs may have been erected. Many were monuments to the dead.

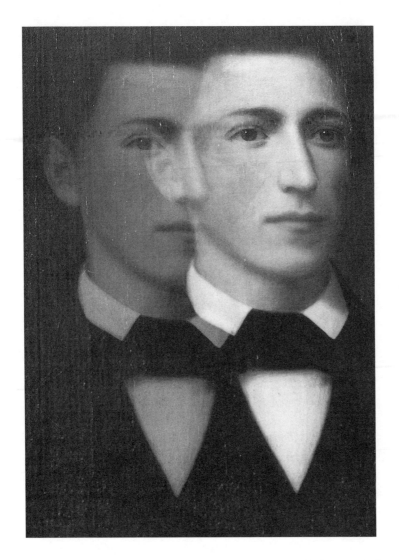

who could know what times he looked at Henry's face and thought . . . *what cannot I do with this willing flesh and bone if I wish; this flesh and bone and spirit which stemmed from the same source that mine did, but which sprang in quiet peace and contentment and ran in steady even though monotonous sunlight, where that which he bequeathed me sprang in hatred and outrage and unforgiving and ran in shadow.*

| *Absalom, Absalom!* |

Double-exposure photograph of a portrait of an unknown young man, Cedar Oaks, Oxford

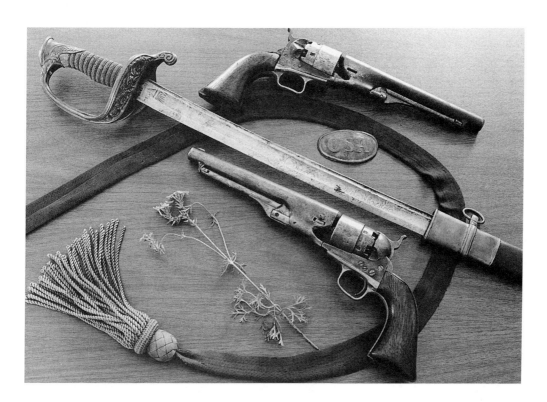

the house where he would be lying in the parlor now, in his regimentals (sabre too) and where Drusilla would be waiting for me beneath all the festive glitter of the chandeliers, in the yellow ball gown and the sprig of verbena in her hair, holding the two loaded pistols

| *The Unvanquished* |

A sprig of verbena among Civil War relics (University of Mississippi Museums)

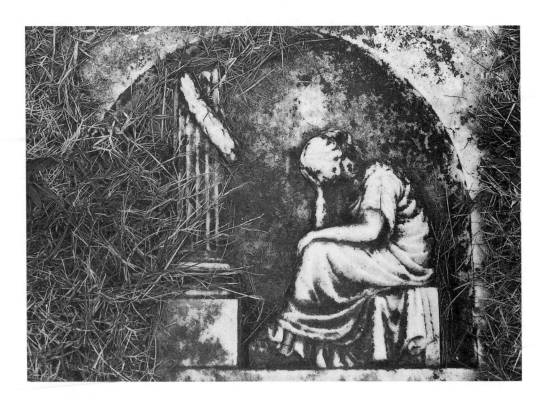

He had to brush the clinging cedar needles from this one also to read it, watching these letters also emerge beneath his hand, wondering quietly how they could have clung there, not have been blistered to ashes at the instant of contact with the harsh and unforgiving threat: *Judith Coldfield Sutpen. Daughter of Ellen Coldfield. Born October 3, 1841. Suffered the Indignities and Travails of this World for 42 Years, 4 Months, 9 Days, and went to Rest at Last February 12, 1884. Pause, Mortal; Remember Vanity and Folly and Beware.*

| *Absalom, Absalom!* |

Gravestone in Ripley Cemetery, Tippah County. This uncovered grave marker might visually express Judith Sutpen's despairing epitaph. Several yards away from this stone and to the rear of W. C. Falkner's monument lies the nearly indecipherable gravestone of Emeline Falkner, who was probably the colonel's mulatto mistress.

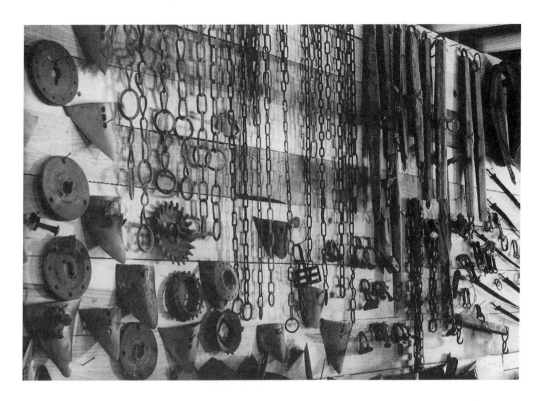

the wall pegs dependant with plowlines and plow-collars and hames and trace-chains, and the desk and the shelf above it on which rested the ledgers in which McCaslin recorded the slow outward trickle of food and supplies and equipment which returned each fall as cotton made and ginned and sold (two threads frail as truth . . . yet cable-strong to bind for life them who made the cotton to the land their sweat fell on).

| *Go Down, Moses* |

Harness, trace chains, plow bolts, collars, and other farming implements (Collection of Walter R. Porter, Myrtle, Union County, Mississippi)

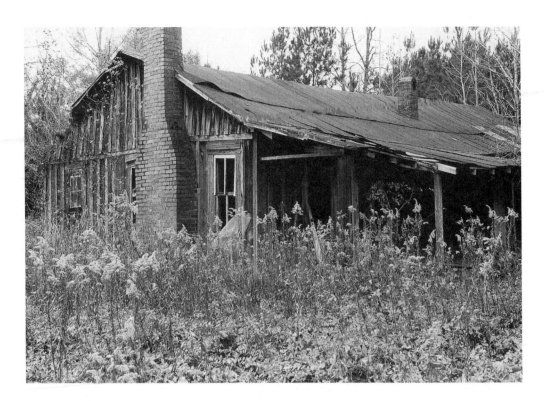

the wagon stopped before a paintless two-room house identical almost with the dozen others it had stopped before even in the boy's ten years, and again, as on the other dozen occasions, his mother and aunt got down and began to unload the wagon, although his two sisters and his father and brother had not moved.

"Likely hit ain't fitten for hawgs," one of the sisters said.

"Nevertheless, fit it will and you'll hog it and like it," his father said. "Get out of them chairs and help your Ma unload."

| "Barn Burning" |

Tenant cabin near Greenfield Farm, Lafayette County

56

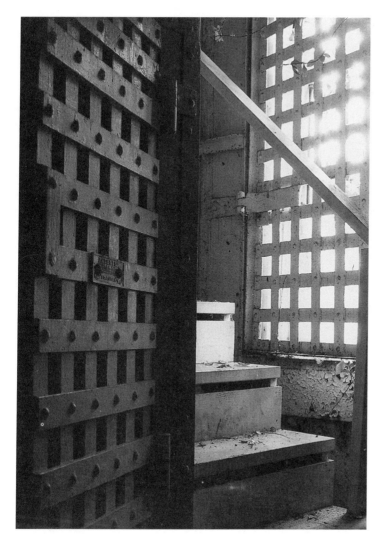

The last trumpet-shaped bloom had fallen from the heaven tree at the corner of the jail yard . . . and at night now the ragged shadow of full-fledged leaves pulsed upon the barred window. . . . the negro murderer leaned there, his face checkered by the shadow of the grating in the restless interstices of leaves, singing in chorus with those along the fence below.

Sometimes during the day he sang also, alone . . . "One day mo! Aint no place fer you in heavum! Aint no place fer you in hell! Aint no place fer you in whitefolks' jail!"

| *Sanctuary* |

Interior stair and cell door, old Webster County jail, Walthall, Mississippi. Faulkner believed that a jail was "the true record" of a county's human history. He felt that the old Oxford (Jefferson) jail, built in 1871, had been carefully and tastefully constructed. (It was demolished after 1971.) This cell door in the abandoned Webster County jail is very similar in design to the old Oxford jail-cell doors.

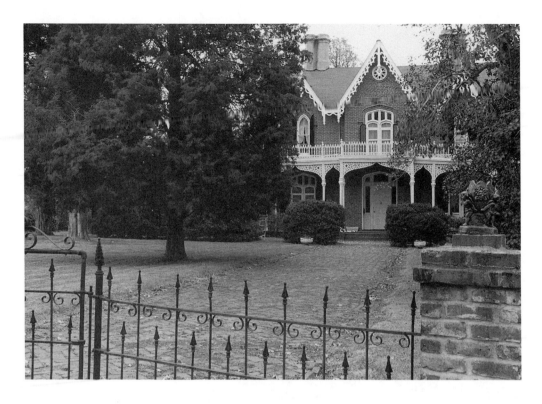

the brick doll's house in which Horace and Narcissa lived. . . . It was trimmed with white and it had mullioned casements brought out from England.

| *Flags in the Dust* |

Cedarhurst, the Bonner-Belk house, Holly Springs. Built in 1858, it is noted for its Gothic Revival style: peaked gables with gingerbread scrollwork, ornamental windows, and wrought-iron fence.

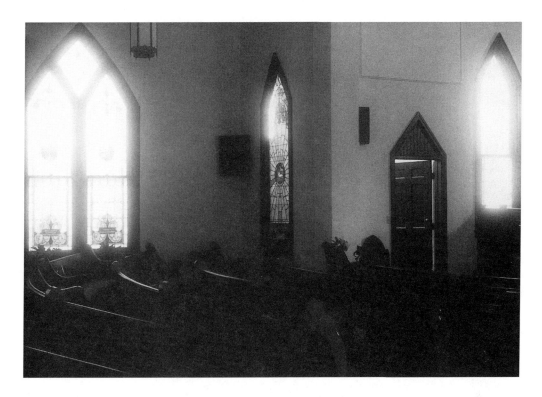

In the middle of the sermon she sprang from the bench and began to scream,
to shriek something toward the pulpit . . . where her husband had ceased talking,
leaning forward with his hands raised and stopped. Some people nearby tried to
hold her but she fought them, and they told Byron how she stood there, in the
aisle now, shrieking and shaking her hands at the pulpit where her husband
leaned with his hand still raised and his wild face frozen. . . . They did not know
whether she was shaking her hands at him or at God.

| *Light in August* |

Cleveland Street Presbyterian Church sanctuary, New Albany, Mississippi. This fog-filtered photograph
suggests an atmosphere of dream or delirium. Down the street was the clapboard house where Faulkner
was born in 1897. During the 1940s he was saddened by the demolition of the Cumberland Presbyterian
Church on South Lamar Avenue in Oxford. That antebellum church, which was the site of a jubilant inau-
guration of Confederate troops in 1861, would have appealed to the delirious imagination of Gail High-
tower, the defrocked minister in *Light in August*. For that novel Faulkner may also have had in mind
Oxford's equally historic First Presbyterian Church, which was torched by Federal troops in 1864 but
recovered and remodeled in 1881.

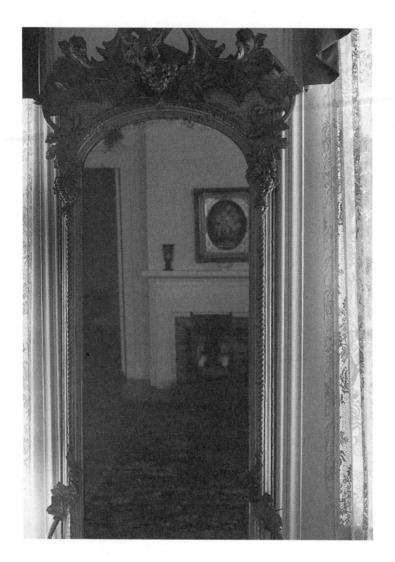

to the right of the entrance, beside folding doors rolled back upon a dim room emanating an atmosphere of solemn and seldom violated stateliness . . . stood a tall mirror filled with grave obscurity like a still pool of evening water. At the opposite end of the hall checkered sunlight fell in a long slant across the door, and from somewhere beyond the bar of sunlight a voice rose and fell.

| *Flags in the Dust* |

Parlor mirror at Cedar Oaks, Oxford

except Jason he has never given me one moment's sorrow since I first held him in my arms I knew then that he was to be my joy and my salvation I thought that Benjamin was punishment enough for any sins I have committed . . . I see now that I must pay for your sins as well as mine what have you done what sins have your high and mighty people visited upon me but you'll take up for them you always have found excuses for your own blood

| *The Sound and the Fury* |

Time and haunting memory, Lochinvar, Pontotoc County

All the men in the village worked in the mill or for it. It was cutting pine. It had been there seven years and in seven years more it would destroy all the timber within its reach.

| *Light in August* |

Lumber mill, Calhoun County

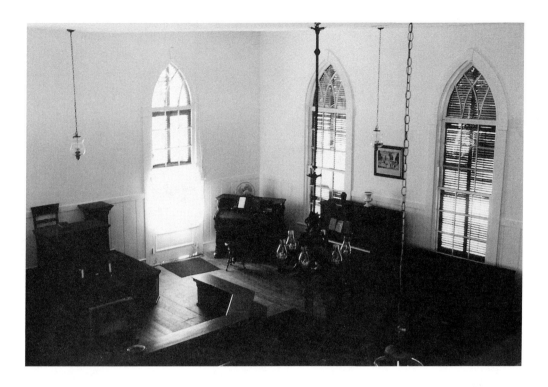

Granny sent for them, sent out word back into the hills where they lived in dirt-floored cabins, on the little poor farms without slaves. It took three or four times to get them to come in, but at last they all came. . . . I reckon this was the first church with a slave gallery some of them had ever seen, with Ringo and the other twelve sitting up there in the high shadows.

| *The Unvanquished* |

View from the slave gallery, Freedonia Church, Panola County. Built in 1848, this small, attractively appointed country church was named "Freedonia" because "all denominations are free to worship here." It was constructed of logs and hand-hewn timber with interior plasterwork accomplished by slaves. Like College Hill Church, it had a separate entrance to the upstairs slave gallery at the rear of the sanctuary.

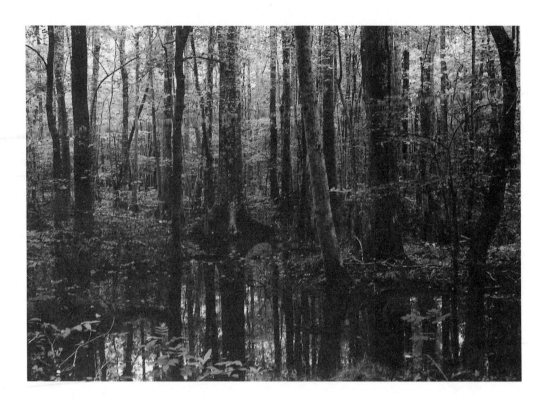

Then he saw the bear. It did not emerge, appear: it was just there, immobile . . . dimensionless against the dappled obscurity, looking at him. . . . Then it was gone. It didn't walk into the woods. It faded, sank back into the wilderness without motion as he had watched a fish, a huge old bass, sink back into the dark depths of its pool and vanish without even any movement of its fins.

| *Go Down, Moses* |

Swampland in Tallahatchie County

64

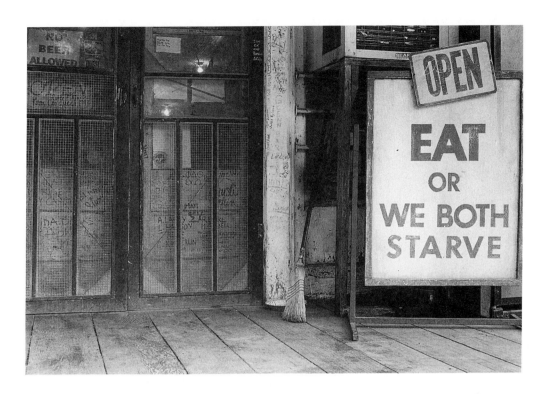

Fresh Catfish Today the board stated in letters of liquefied chalk, and through the screen doors beyond it came a smell of refrigerated food—cheese and pickle and such—with a faint overtone of fried grease.

| *Flags in the Dust* |

Sign at Taylor Grocery, Taylor, Lafayette County

To Temple, sitting in the cottonseed-hulls and the corncobs, the sound was no louder than the striking of a match . . . and she sat there . . . looking at Popeye's tight back and the ridges of his coat across the shoulders as he leaned out the door, the pistol behind him, against his flank, wisping thinly along his leg.

He turned and looked at her. He waggled the pistol slightly and put it back in his coat, then he walked toward her. Moving he made no sound at all . . . it was as though sound and silence had become inverted . . . and she began to say Something is going to happen to me.

| *Sanctuary* |

Barn interior, Montgomery County, Mississippi

like something moving forever and without progress across an urn

| *Light in August* |

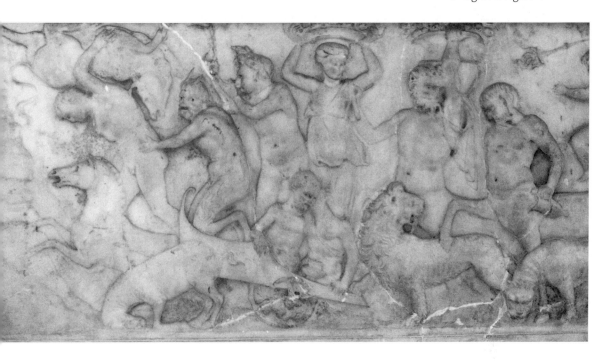

her entire appearance suggested some symbology out of the old Dionysic times—
honey in sunlight and bursting grapes, the writhen bleeding of the crushed
fecundated vine beneath the hard rapacious trampling goat-hoof.

| *The Hamlet* |

Marble frieze (University of Mississippi Museums). This relief panel, described as the *Triumph of Bacchus,*
is on a sarcophagus of uncertain provenance, dating perhaps to 1550 C.E. It is one of several architectural
fragments in the David M. Robinson Memorial Collection of Greek and Roman Antiquities at the Univer-
sity of Mississippi. Although Faulkner may never have seen this panel, it certainly complements lines
from one of his favorite poems, John Keats's "Ode on a Grecian Urn": "Thou foster-child of silence and
slow time / . . . / . . . fair attitude! with brede / Of marble men and maidens overwrought"—recurring
images in Faulkner's novels.

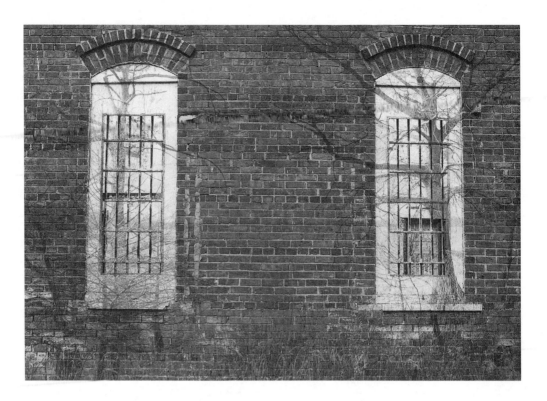

they were sleeping restlessly beneath the sound of the rain on the tin roof when at midnight the sudden glare of the electric bulbs and the guards' voices waked them and they heard the throbbing of the waiting trucks.

"Turn out of there!" the deputy shouted. He was fully dressed—rubber boots, slicker, and shotgun. "The levee went out at Mound's Landing an hour ago. Get up out of it!"

| *If I Forget Thee, Jerusalem* |

Abandoned prison building, Mississippi State Penitentiary (Parchman Farm), Sunflower County. Parchman is the oldest penitentiary (1901) and the only maximum-security prison in Mississippi. It is located on a nineteen-thousand-acre plantation in the Delta, about seventy-three miles southwest of Oxford. Inmates work on the prison farm, like Faulkner's Tall Convict in "Old Man," and in manufacturing workshops. Before 1974 Parchman was known for its cruel and unusual treatment of black prisoners. Because of state economic restrictions, the penitentiary had few employees and was run primarily by inmate trustees, who guarded and disciplined other inmates. As described in Faulkner's novella "Old Man" (which is paired with the novella "The Wild Palms" in *If I Forget Thee, Jerusalem*), the great Mississippi River flood of 1927 inundated most of the Delta. In Washington County, workers, mostly blacks, and convicts were put to work at an attempt to save the failing levees from the rampaging river water. More than thirteen thousand evacuees near Greenville were gathered from farms and evacuated to the crest of an unbroken levee, where they were marooned without drinking water or food until boats arrived to rescue white women and children.

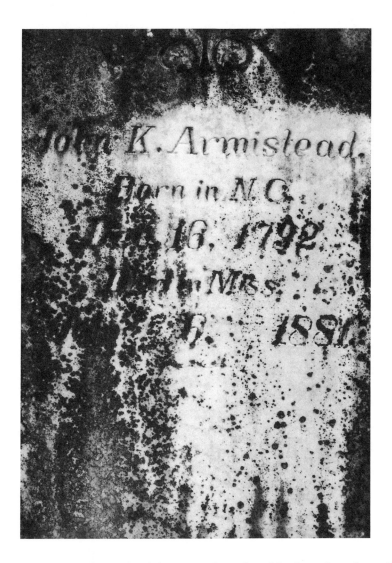

They came from the Atlantic seaboard and before that, from England and the Scottish and Welsh Marches, as some of the names would indicate—Turpin and Haley and Whittington, McCallum and Murray and Leonard and Littlejohn, and other names like Riddup and Armstid and Doshey. . . . They brought no slaves and no Phyfe and Chippendale highboys; indeed, what they did bring most of them could (and did) carry in their hands.

| *The Hamlet* |

Gravestone in a north Mississippi cemetery for John K. Armstead (1792-1881), an early settler from North Carolina

The settlement had the records; even the simple dispossession of Indians begot in time a minuscule of archive, let alone the normal litter of man's ramshackle confederation against environment . . . in this case, a meagre, fading, dogeared, uncorrelated, at times illiterate sheaf of land grants and patents and transfers and deeds, and tax- and militia-rolls, and bills of sale for slaves . . . and liens and mortgages, and listed rewards for escaped or stolen Negroes and other livestock, and diary-like annotations of births and marriages and deaths and public hangings and land-auctions.

| *Requiem for a Nun* |

Nineteenth-century land grant records, Chancery Clerk's Office, Lafayette County Courthouse

I live at a place named Contalmaison. My father built it and named it. He was a Choctaw chief named Francis Weddel, of whom you have probably not heard. He was the son of a Choctaw woman and a French émigré. . . . My father drove to Washington once in his carriage to remonstrate with President Jackson about the Government's treatment of his people, sending on ahead a wagon of provender and gifts and also fresh horses for the carriage.

| "Mountain Victory" |

Greenwood LeFlore's carriage in a glass enclosure off the Natchez Trace Parkway, near French Camp, Choctaw County, Mississippi. The story of Saucier Weddel returning from the Civil War to Contalmaison, his estate in Mississippi, "Mountain Victory" refers to a carriage journey his father, Francis Weddel, took to confront President Andrew Jackson about the rights of the Choctaw Indians. The encounter with Jackson, a variation of this story, is narrated in "Lo!" Both these short stories are based on the life of Greenwood LeFlore (1800–1865), who was born at LeFleur's Bluff, the future site of the Mississippi state capitol building at Jackson. (See also "The Golden Dome" in act 2 of *Requiem for a Nun*.) His father was Louis LeFleur, a French Canadian trader, and his mother, Rebecca Cravat, was the niece (continued next page)

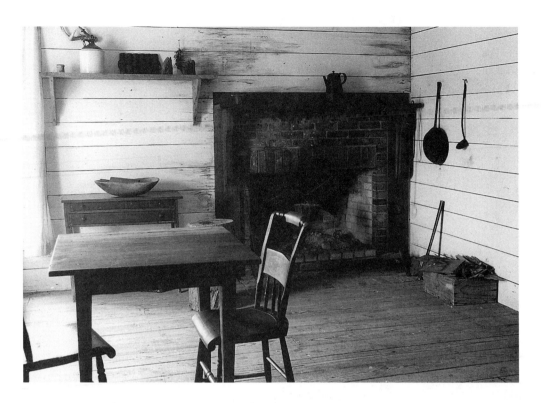

they married and he rented the cabin from Carothers Edmonds and built a fire on the hearth on their wedding night as the tale told how Uncle Lucas Beauchamp, Edmonds' oldest tenant, had done on his forty-five years ago and which had burned ever since; and he would rise and dress and eat his breakfast by lamplight to walk the four miles to the mill by sunup, and exactly one hour after sundown he would enter the house again.

| *Go Down, Moses* |

of Pushmahata, chief of the Choctaw nation. Greenwood LeFlore became a large landowner in Carroll County, where he built the stately mansion Malmaison. He served in both houses of the state legislature and was elected the last chief of the Choctaws east of the Mississippi. He was involved with the Treaty of Dancing Rabbit Creek (1830), which removed most of the Choctaws from Mississippi to Oklahoma, In 1831 LeFlore traveled to Washington in an elegant carriage to appeal to President Jackson for the rights his people had been denied in their hasty removal.

(*above*) Farmhouse kitchen, Florewood River Plantation State Park, near Greenwood, Leflore County, Mississippi. This park re-creates a full-scale 1850s cotton plantation. The plantation, town, and county all take their names from Greenwood LeFlore. Land was partitioned from Carroll County for the formation of Leflore County in 1871.

there still remains one faint diffusion since everywhere you look about the dark panorama you still see them, faint as whispers: the faint and shapeless lambence of blooming dogwood returning loaned light . . . as the phantoms of candles would.

| *The Town* |

Blooming dogwood, Marshall County, Mississippi

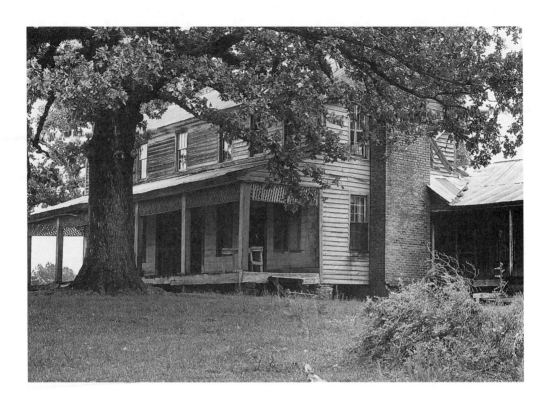

a sprawling rambling edifice partly of sawn boards and partly of logs, unpainted and of two storeys in places and known as Littlejohn's hotel, where behind a weathered plank nailed to one of the trees and lettered ᴿOOMƧ AND BORD drummers and livestock-traders were fed and lodged.

| *The Hamlet* |

The James Drane house, Choctaw County, Mississippi. Nineteenth-century village boardinghouses have vanished from north Mississippi. This two-story country house with a veranda, built by Colonel James Drane in 1848, is similar to, but smaller than, the rambling Littlejohn hotel in *The Hamlet*. Several years after this photograph was taken in 1971, the house was moved to the historic area on the Natchez Trace Parkway at French Camp, Mississippi, and restored.

When it bloomed in the spring and it rained the smell . . . began to come into the house at twilight either it would rain more at twilight or there was something in the light itself but it always smelled strongest then until I would lie in bed thinking when will it stop when will it stop. . . . Sometime I could put myself to sleep saying that over and over until after the honeysuckle got all mixed up in it the whole thing came to symbolise night and unrest I seemed to be lying neither asleep nor awake looking down a long corridor of gray halflight where all stable things had become shadowy paradoxical all I had done shadows.

| *The Sound and the Fury* |

Honeysuckle, Lafayette County

Calico-coated, small-bodied, with delicate legs and pink faces in which their mismatched eyes rolled wild and subdued, they huddled, gaudy motionless and alert, wild as deer, deadly as rattlesnakes, quiet as doves. The men stood at a respectful distance, looking at them.

| *The Hamlet* |

In 1922, when Faulkner's uncle J. W. T. Falkner II campaigned for reappointment as judge of the Third District Court, he bought a Model T Ford, and his nephew William was the chauffeur. On one trip they spent a night at a boardinghouse in Pittsboro, the seat of Calhoun County. Circuit court week in February or July was a popular occasion for horse trading, and according to Faulkner's brother John: "Bill was sitting on the front porch of the boardinghouse late that evening when some men brought in a string of ponies wired together with barbed wire. They put them in a lot just across the road . . . and the next morning auctioned them off." After the traders sold the ponies, they departed, leaving a gate open, and the ponies stampeded past their new owners to freedom. This incident, fabricated with barbed wire, was the germ for Faulkner's "spotted horses" tale. Among the horse and livestock traders in north Mississippi between 1890 and 1930, Lafayette J. Bright and his nephew Walton Reed from Choctaw County were fairly well-known. According to Bright's daughter, they traded extensively through the surrounding counties of north and central Mississippi, and during one year alone as many as thirty-one carloads of horses, a few mustangs and calicoes, were brought to them from Texas by rail. Fayette *(fate)* Bright, a shrewd and laconic trader, bought and sold the horses; Reed, an agile and dapper Texas-bred cowboy, rode and occasionally bronco-busted them for the customers. Perhaps Faulkner encountered them in Pittsboro and used them as models for his fabled Pat Stamper and the Texan Buck Hipps.

Lena thinks. She thinks of herself as already moving, riding again, thinking *Then it will be as I f I were riding for a half mile before I even got into the wagon, before the wagon even got to where I was waiting, and that when the wagon is empty of me again it will go on for a half mile with me still in it* She waits, not even watching the wagon now, while thinking goes idle and swift and smooth, filled with nameless kind faces and voices: *Lucas Burch? You say you tried in Pocahontas? This road? It goes to Springvale. You wait here. There will be a wagon passing soon that will take you as far as it goes.*

| *Light in August* |

I dont suppose anybody ever deliberately listens to a watch or a clock. You dont have to. You can be oblivious to the sound for a long while, then in a second of ticking it can create in the mind unbroken the long diminishing parade of time you didn't hear. Like Father said down the long and lonely light-rays you might see Jesus walking, like. And the good Saint Francis that said Little Sister Death, that never had a sister.

| *The Sound and the Fury* |

June 2, 1910, Quentin Compson's morning reverie—a photographic invention

When I was a boy I first learned how much better water tastes when it has set a while in a cedar bucket. Warmish-cool, with a faint taste like the hot July wind in cedar trees smells. It has to set at least six hours, and be drunk from a gourd. . . .

And at night it is better still. I used to lie on the pallet in the hall, waiting until I could hear them all asleep, so I could get up and go back to the bucket. It would be black, the shelf black, the still surface of the water a round orifice in nothingness, where before I stirred it awake with the dipper I could see maybe a star or two in the bucket, and maybe in the dipper a star or two before I drank.

| *As I Lay Dying* |

Cedar bucket and gourd dipper (Atlanta History Center)

She came and sat in a chair before the hearth. There was a little fire there.
. . . She built a good blaze. She told a story. She talked like her eyes looked, like
her eyes watching us and her voice talking to us did not belong to her. Like she
was living somewhere else, waiting somewhere else.　　| "That Evening Sun" |

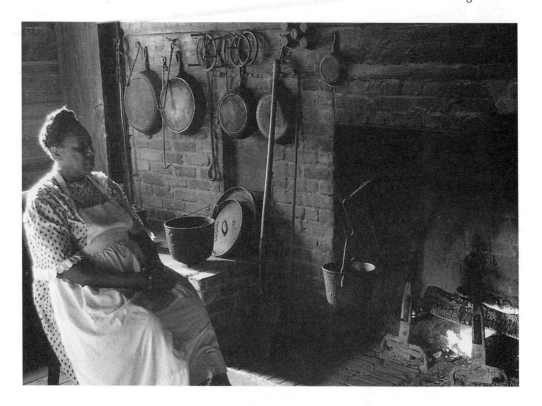

She sat . . . motionless . . . her tiny gnarled hands immobile again on the white
apron, the shrunken and tragic mask touched here and there into highlight by
the fire.

| *Go Down, Moses* |

Attendant and kitchen at Patterson-Marrett Farmhouse, Westville Village, near Lumpkin, Georgia. Westville
is a living-history museum that depicts the architecture and crafts of a nineteenth-century village in the
Deep South.

just as you had seen the old house too, been familiar with how it would look before you even saw it, became large enough to go out there one day with four or five other boys of your size and age and dare one another to evoke the ghost, since it would have to be haunted, could not but be haunted . . . the rotting shell with its sagging portico and scaling walls

| *Absalom, Absalom!* |

Ghost image of a ruined mansion

Then the little locomotive shrieked and began to move: a rapid churning of exhaust, a lethargic deliberate clashing of slack couplings travelling backward along the train, the exhaust changing to the deep slow clapping bites of power as the caboose too began to move and from the cupola he watched the train's head complete the first and only curve in the entire line's length and vanish into the wilderness.

| *Go Down, Moses* |

Vulcan locomotive 2609 at Georgia Agrirama, near Tifton, Georgia. Built in 1917 by the Vulcan Iron Works of Wilkes-Barre, Pennsylvania, this small, steam locomotive ran on a thirty-six-inch-wide track and was preferred by logging and industrial concerns because a smaller engine cost less to purchase and operate. Many sawmills in the Deep South used narrow-gauge trains to transport logs from the forest to the mills.

we went into Mother's room. There was a fire. It was rising and falling on the walls. There was another fire in the mirror. I could smell the sickness.

| *The Sound and the Fury* |

The entire staircase was on fire. . . . Quentin could see it: the light thin furious creature making no sound at all now, struggling with silent and bitter fury, clawing and scratching and biting at the two men who held her, who dragged her back and down the steps as the draft created by the open door seemed to explode like powder among the flames as the whole lower hall vanished.

| *Absalom, Absalom!* |

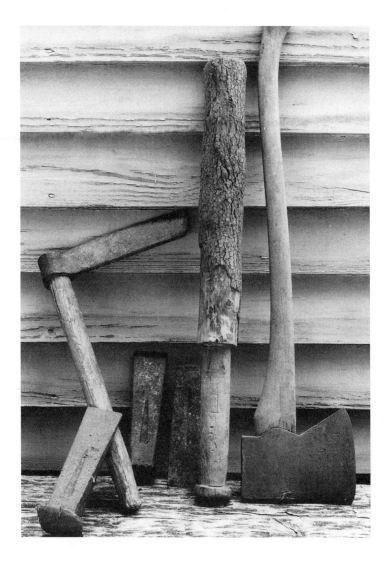

We rid on past the church. . . . We tied the mule to a sapling and hung our dinner bucket on a limb, and with pap toting Killegrew's froe and maul and the wedges and me toting our ax, we went on to the board tree where Solon and Homer Bookwright, with their froes and mauls and axes and wedges, was setting on two upended cuts.

| "Shingles for the Lord" |

Wedges, froe, maul and ax (Atlanta History Center)

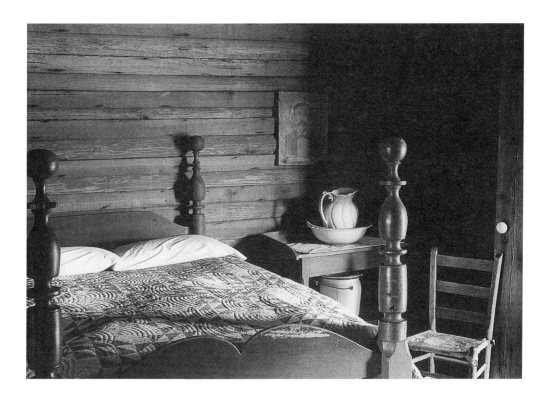

The quilt is drawn up to her chin, hot as it is, with only her two hands and her face outside. She is propped on the pillow, with her head raised so she can see out the window, and we can hear him every time he takes up the adze or the saw. If we were deaf we could almost watch her face and hear him, see him.

| *As I Lay Dying* |

Bedroom in the grist miller's house at Georgia Agrirama, Museum of Agriculture and Historic Village, a ninety-five acre site in Tift County with thirty-five fully restored farm buildings of the postbellum South

a small woman, almost tiny, who in the succeeding forty years seemed to have grown even smaller, in the same clean white headcloth and apron which he first remembered

| *Go Down, Moses* |

Costumed interpreter, bedroom in a dogtrot farmhouse at Georgia Agrirama

Setting back there in that truck, with him by her now and the baby that hadn't never stopped eating . . . and her looking out and watching the telephone poles and the fences passing like it was a circus parade. Because after a while I says, "Here comes Saulsbury" and she says,

"What?" and I says,

"Saulsbury, Tennessee" and I looked back and saw her face. And it was like it was already fixed and waiting to be surprised, and that she knew that when the surprise come, she was going to enjoy it. And it did come and it did suit her. Because she said,

"My, my. A body does get around. Here we aint been coming from Alabama but two months, and now it's already Tennessee."

| *Light in August* |

Mississippi/Tennessee state line, Highway 15, Tippah County. At the conclusion of *Light in August* the road on which the furniture dealer drives north in Mississippi to Tennessee may have been either what is now called Highway 7 in Benton County or Highway 15 in Tippah County. Either road would have taken him and his passengers, Lena Grove and Byron Bunch, toward Jackson, Tennessee, but to pass Saulsbury would require a detour on Tennessee route 57. Faulkner may have had the first road in mind because it winds northward from Oxford past Holly Springs to Grand Junction, Tennessee, but the second road closely parallels the route of Colonel Falkner's railroad from Ripley to Middleton, Tennessee.

Notes

Frontispiece: Doyle, *Faulkner's County,* 24–25; *Faulkner in the University,* 74.

p. 7: John Faulkner, *My Brother Bill,* 271–72.

p. 9: Doyle, *Faulkner's County,* 104; William Lewis, Jr., communication with the author, March 21, 2008.

p. 10: Blotner, *Faulkner,* 1:76.

p. 12: Ibid., 1:16.

p. 15: Cullen and Watkins, *Old Times in the Faulkner Country,* 97–98.

p. 16: Doyle, *Faulkner's County,* 330–31.

p. 18: Blotner, *Faulkner,* 1:176–77. See also Cullen and Watkins, *Old Times in the Faulkner Country,* 27–29.

p. 19: *Mississippi: The WPA Guide,* 259.

p. 24: Hines, *William Faulkner and the Tangible Past,* 47.

p. 29: Curator William Griffith, e-mail to the author, February 18, 2008.

p. 30: Blotner, *Faulkner,* 1:44; Tommy Covington, e-mail to the author, February 21, 2008.

p. 31: *Mississippi: The WPA Guide,* 14.

p. 33: "Brice's Crossroads, Battle of." In *The Encyclopedia of Southern History,* 147.

p. 35: Wolff with Watkins, *Talking About William Faulkner,* 45.

p. 36: Ibid., 123.

p. 39: One of the three examples, bearing the single name "Ludie," is in the McCarron Place in Holly Springs; the other two, "Jane T. Cook" and "Jennie Garland," are in the relics collection at the University of Mississippi Museums. The first inscription lacks contrast when photographed; the second, which Faulkner may have been familiar with, is almost indecipherable on a glass shard; the third, shown here, is the best image photographically.

p. 40: Hines, *William Faulkner and the Tangible Past,* 52.

p. 41: Blotner, *Faulkner,* 1:631–32; see also Cullen and Watkins, *Old Times in the Faulkner Country,* 71.

p. 50: William Lewis, Jr., communication with author, March 27, 2008; Hines, *William Faulkner and the Tangible Past,* 54.

p. 51: There are several Chickasaw Indian mounds in Faulkner country, including at least five small mounds In Lafayette County, one of which is believed submerged under Sardis Lake. However, the site Faulkner refers to is probably the Ingomar Mounds in Union County, eight miles south of New Albany. This temple mound is the largest in north Mississippi. Excavations by the Smithsonian Institution in 1885 may have revealed that it was built after Hernando de Soto's encampment in 1541 because a green-glass bottle fragment and a silver plate with a Spanish coat of arms were said to have been discovered there (see Brown, *Archeology of Mississippi,* 19). Because this mound proved difficult to photograph, the Owl Creek Mounds in nearby Chickasaw County were chosen instead.

p. 54: Williamson, *William Faulkner and Southern History,* 64–70.

p. 57: Hines, *William Faulkner and the Tangible Past,* 100–102.

p. 59: Doyle, *Faulkner's County,* 192–94.

p. 63: Kempe, *The Pelican Guide to Old Homes of Mississippi,* 2:129. See also Hines, *William Faulkner and the Tangible Past,* 81–82.

p. 68: Barry, *Rising Tide,* 195–96, 312–14,

p. 76: Blotner, *Faulkner,* 1:340; John Faulkner, *My Brother Bill,* 158–59; Eva Bright, interview with author, Ackerman, Mississippi, June 29, 1974.

Selected Bibliography

Aiken, Charles S. "Faulkner's Yoknapatawpha County: A Place in the American South." *Geographical Review* 69 (July 1979): 331–48.

Barry, John M. *Rising Tide: The Great Mississippi Flood of 1927 and How It Changed America.* New York: Simon & Schuster, 1997.

Blotner, Joseph. *Faulkner: A Biography.* 2 vols. New York: Random House, 1974. 1 vol. New York: Random House, 1984.

Brown, Calvin S. "Appendix: Faulkner's Geography and Topography." In *A Glossary of Faulkner's South,* 223–41. New Haven: Yale University Press, 1976.

———. *Archeology of Mississippi.* Oxford: University of Mississippi, 1926. Reprint, Jackson: University Press of Mississippi, 1992.

Cofield, Jack. *William Faulkner: The Cofield Collection.* Oxford, Miss.: Yoknapatawpha Press, 1978.

Cullen, John B., with Floyd C. Watkins. *Old Times in the Faulkner Country.* Chapel Hill: University of North Carolina Press, 1961.

Dain, Martin J. *Faulkner's County: Yoknapatawpha.* New York: Random House, 1964.

———. *Faulkner's World: The Photographs of Martin J. Dain.* Edited by Tom Rankin. Jackson: University Press of Mississippi, 1997.

Doyle, Don H. *Faulkner's County: The Historical Roots of Yoknapatawpha.* Chapel Hill: University of North Carolina Press, 2001.

The Encyclopedia of Southern History. Edited by David C. Roller and Robert W. Twyman. Baton Rouge: Louisiana State University Press, 1979.

Evans, Walker. "Faulkner's Mississippi." *Vogue* 10 (October 1948): 144–49.

Faulkner, John. *My Brother Bill: An Affectionate Reminiscence.* New York: Trident Press, 1963.

Faulkner, William. *Absalom, Absalom!* 1936. Corrected text. New York: Vintage,1990.

———. *As I Lay Dying.* 1930. Corrected text. New York: Vintage, 1990.

———. *Collected Stories.* New York: Random House, 1950.

———. *Essays, Speeches and Public Letters.* Edited by James B. Meriwether. New York: Random House, 1965.

———. *The Faulkner Reader: Selections from the Works of William Faulkner.* New York: Random House, 1954.

———. *Go Down, Moses.* 1942. New York: Vintage, 1990.

———. *The Hamlet.* 1940. Corrected text. New York: Vintage, 1991.

———. *If I Forget Thee, Jerusalem: The Wild Palms.* Corrected text. New York: Vintage, 1995. Published in 1939 as *The Wild Palms.*

———. *Intruder in the Dust.* 1948. New York: Vintage, 1991.

———. *Light in August.* 1932. Corrected text. New York: Vintage, 1990.

———. *Lion in the Garden: Interviews with William Faulkner 1926–1962.* Edited by James B. Meriwether and Michael Millgate. New York: Random House, 1968.

———. *The Mansion.* New York: Random House, 1959.

———. *The Marble Faun.* 1924. *A Green Bough.* 1933. Republished in 1 vol. New York: Random House, 1965.

———. *Novels 1926–1929: Soldier's Pay, Mosquitoes, Flags in the Dust, The Sound and the Fury.* Edited by Joseph Blotner and Noel Polk. New York: Library of America, 2006.

———. *The Reivers: A Reminiscence.* 1962. New York: Vintage, 1992.

———. *Requiem for a Nun.* 1951. New York: Vintage, 1975.

———. *Sanctuary.* 1931. Corrected text. New York: Vintage, 1993.

———. *The Sound and the Fury.* 1929. Corrected text. New York: Vintage, 1990.

———. *The Town.* New York: Random House, 1957.

———. *Uncollected Stories.* Edited by Joseph Blotner. New York: Random House, 1979.

————. *The Unvanquished.* 1938. Corrected text. New York: Vintage, 1991.

Faulkner in the University: Class Conferences at the University of Virginia, 1957–1958. Edited by Frederick L. Gwynn and Joseph L. Blotner. Charlottesville: University of Virginia Press, 1959.

Gutting, Gabriele. *Yoknapatawpha: The Function of Geographical and Historical Facts In William Faulkner's Fictional Picture of the Deep South.* Frankfurt am Main: Peter Lang, 1992.

Hamblin, Robert W., and Charles A. Peek, eds. *A William Faulkner Encyclopedia.* Westport, Conn.: Greenwood Press, 1999.

Hawkins, E. 0. "Jane Cook and Cecilia Farmer." *Mississippi Quarterly* 18 (Fall 1965): 248–51.

Haynes, Jane Isbell. "Another Source for Faulkner's Inscribed Window Panes." *Mississippi Quarterly* 39 (Summer 1986): 365–67.

Hines, Thomas S. *William Faulkner and the Tangible Past: The Architecture of Yoknapatawpha.* Berkeley: University of California Press, 1996.

Irwin, John T. *Doubling and Incest, Repetition and Revenge: A Speculative Reading of Faulkner.* Baltimore: Johns Hopkins University Press, 1975.

Kempe, Helen Kerr. *The Pelican Guide to the Old Homes of Mississippi.* Vol. II, *Columbus and the North.* Gretna, La.: Pelican, 1977.

McHaney, Thomas L. "The Falkners and the Origins of Yoknapatawpha County: Some Corrections." *Mississippi Quarterly* 25 (Summer 1972): 249–64.

Millgate, Michael. "Faulkner and the South: Some Reflections." In *The South and Faulkner's Yoknapatawpha: The Actual and the Apocryphal,* edited by Evans Harrington and Ann J. Abadie, 195–210. Jackson: University Press of Mississippi, 1977.

Miner, Ward L. *The World of William Faulkner.* Durham, N.C.: Duke University Press, 1952.

Minter, David. *William Faulkner: His Life and Work.* Baltimore: Johns Hopkins University Press, 1980.

Mississippi: The WPA Guide to the Magnolia State. Compiled and written by the Federal Writer's Project of the Works Progress Administration. New York: Viking Press, 1938. Reprint, Jackson: University Press of Mississippi, 1988.

Morris, Willie, and William Eggleston. *Faulkner's Mississippi.* Birmingham, Ala.: Oxmoor House, 1990.

Padgett, John B. "William Faulkner's Rowan Oak." *William Faulkner on the Web.* http://www.mcsr.olemiss.edu/~egjbp/faulkner/rowanoak.html (accessed August 17, 2006).

Smith, Allene De Shazo. *Greenwood Leflore and the Choctaw Indians of the Mississippi Valley.* Memphis: C. A. Davis Printing, 1951.

Snell, Susan. *Phil Stone of Oxford: A Vicarious Life.* Athens: University of Georgia Press, 1991.

Williamson, Joel. *William Faulkner and Southern History.* New York: Oxford University Press, 1993.

Wolff, Sally, with Floyd C. Watkins. *Talking About William Faulkner: Interviews with Jimmy Faulkner and Others.* Baton Rouge: Louisiana State University Press, 1996.